STAMFORD
THROUGH TIME
Christopher Davies

AMBERLEY

Acknowledgements

Thanks are due to The Stamford Survey Group, John Hartley, Lincolnshire Archives office, Peterborough & Stamford NHS Trust and and F. P. Wells for the loan of photographs. As usual, thanks are due to the staff of Stamford Museum for their help in answering my many questions.

First published 2010

Amberley Publishing Plc
Cirencester Road, Chalford,
Stroud, Gloucestershire, GL6 8PE

www.amberley-books.com

Copyright © Christopher Davies, 2010

The right of Christopher Davies to be identified as the Author of this work has been asserted in accordance with the Copyrights, Designs and Patents Act 1988.

ISBN 978 1 84868 481 2

British Library Cataloguing in Publication Data.
A catalogue record for this book is available from the British Library.

Typeset in 9.5pt on 12pt Celeste.
Typesetting by Amberley Publishing.
Printed in the UK.

Introduction

Writing in 1977, The Royal Commission on Historical Monuments noted that Stamford had survived to a large degree undamaged by incongruous modern intrusions. *The tallest buildings are still the church towers, so preserving a traditional skyline.'* However, until the town became the country's first conservation area in 1967, this situation was more one of luck than judgement.

The decision of the Great Northern railway to take the obvious and more direct route north, rather than go through Stamford, certainly saved it from developing into a railway town like Peterborough. Similarly, Jack Pick's failure to further develop his car manufacturing business after the First World War ensured that Stamford did not become another Cowley. It might be argued that the politically inspired delay in enclosing the open fields to the north of the town was also a significant factor in preventing expansion. Such industry as the town has (or had) has largely been located on the outskirts, and as such did not affect the historic core.

The legacy of these unconnected events is a town which is beloved by tourists and film makers alike. In the forward to his book *The Story of Stamford,* Martin Smith referred to Stamford as a 'town which has always encouraged superlatives'. This tendency to hyperbole began as early as 1697 when Celia Feinnes described Stamford 'As fine a built town all of stone as may be seen'. Sir Walter Scott is said to have referred to St Mary's as 'Finest sight between London and Edinburgh'. Others including Pevsner and the historian W. G. Hoskins have praised the town. More recently, television producers have recognised the advantages of filming period dramas in a relatively unspoilt town. Stamford has therefore provided the backdrop to George Elliot's *Middlemarch* and Jane Austen's *Pride and Prejudice.*

To suggest that the town has not changed at all would be wrong. Considerable change has taken place, particularly since the 1930s; and

before the creation of the Conservation Area, a number of interesting buildings were unfortunately demolished. However, the town has to a large extent been able to retain its unique character.

What tends to spoil the town is the odd development that is not in keeping with the surrounding buildings. The Dolby's/Boots store in High Street is a good example, and there are others, not least of which is the old Albert Hall site at the east end of High Street. The town is not a living museum, and we should not seek to make it thus; buildings need to reflect the age in which they are conceived and the needs of that age. However, if Stamford is to retain its status as one of the finest stone towns in England, it needs to embrace the future in a way that acknowledges the past, and tries to achieve a happy blend of old and new.

Stamford is not always the easiest of places to photograph. Its east-west axis often means having to photograph at different times of the day, particularly in high summer. One also becomes very aware of the motor car when photographing the town. Where the Victorian cameraman often stood in the middle of the road to get his photograph, in this day and age it is not an option, even on the quietest of days.

While cars themselves often get in the way of the shot you want, you can at least bide your time until it is moved. The street furniture associated with road transport however, is a different matter and the plethora of signs that punctuate our streets are never more obvious than when taking photographs. A more recent item of street furniture is the ubiquitous street camera most of which seem to be in the most inconvenient places when it comes to taking photographs. In so far as possible, the aim in this book has been to take the modern photograph from the same approximate vantage point as the original. However, this has not always been possible either because the vantage point no longer exists, or because in the intervening years trees have matured sufficiently to obscure the view. In some cases, the street alignment itself has changed. In these cases a different viewpoint has been used where it does not detract from the original picture.

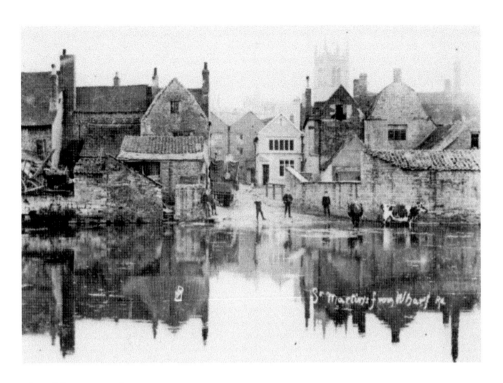

The Old Town Ford

The name Stamford is derived from Stone ford; it then became Stanford. It is appropriate therefore to begin with a photograph of the old town ford. This stood a few yards east of the town bridge and cattle were still being driven across it in the early twentieth century. Now however, walls on both sides of the river give very few clues to the fact that this was once an important crossing point.

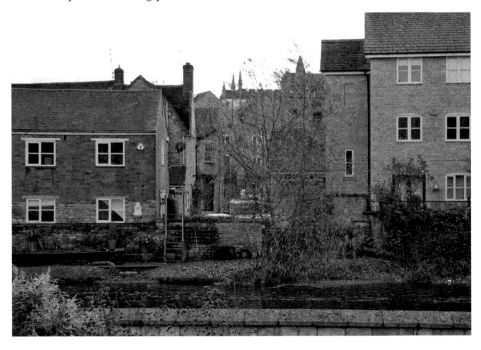

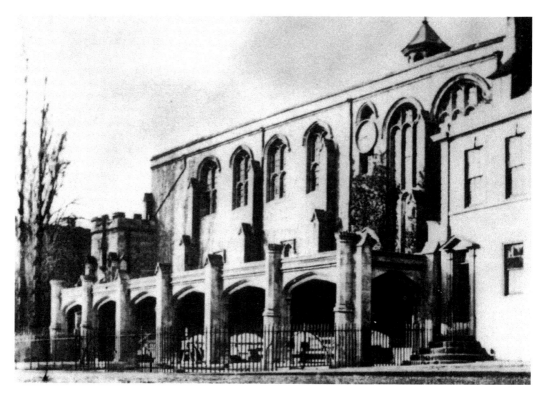

Browne's Hospital

Browne's Hospital was founded in 1475. Built and endowed by William Browne, his wife Margaret and their executors, it was a chantry with two chaplains and alms for ten poor men and two women. The hospital was completely restored in 1870/1 by James Fowler of Louth.

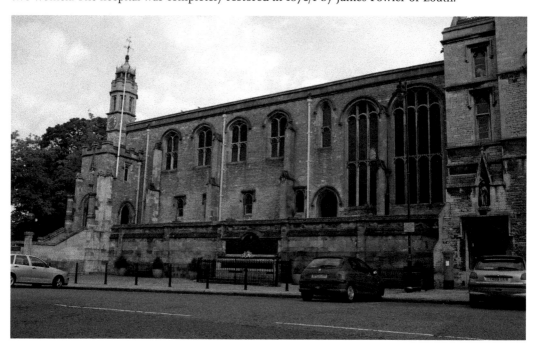

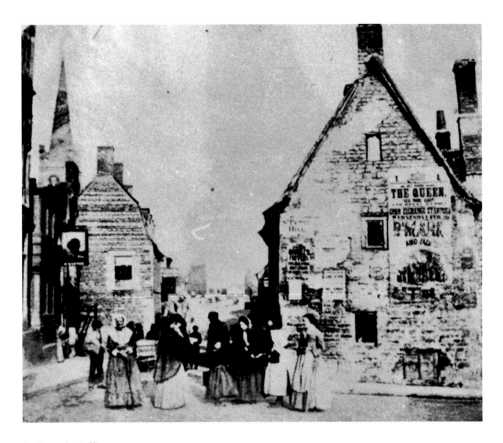

St Peter's Callis

An early photograph showing the original St Peter's Callis. This small medieval building housed up to twelve poor women. In 1859 it was demolished and Edward Barber, a surgeon, left £300 for building a new callis, which was opened in 1863. More modest in its intentions, the new building provided accommodation for just three poor women. It is now a commercial property.

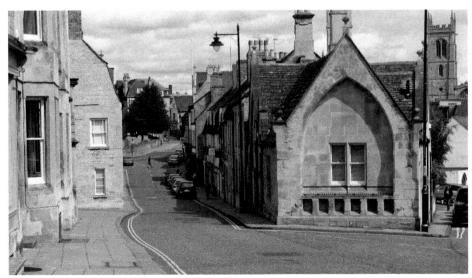

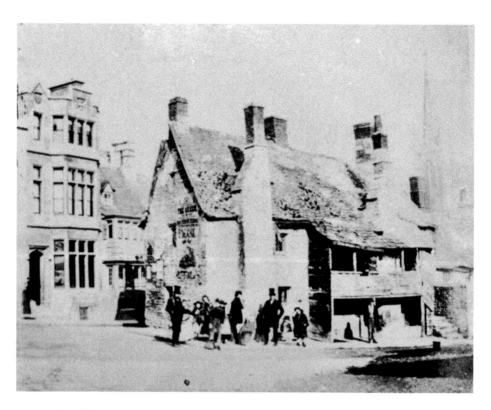

St Peter's Callis, Tower House

Another view of St Peter's Callis and is contemporary with the previous photograph. In this picture the external staircase which provided access to the first floor can be clearly seen. External access to the upper floor was quite common in medieval buildings, as it removed the need for an internal staircase, thus providing more room. In the second photograph it will be noted that Tower House, to the right of the callis has gained another floor.

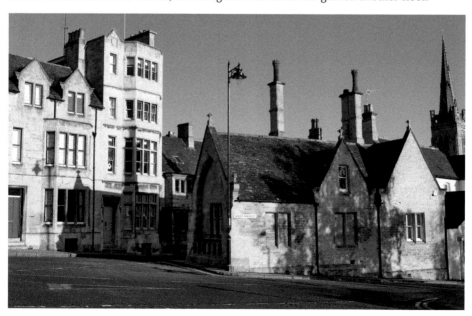

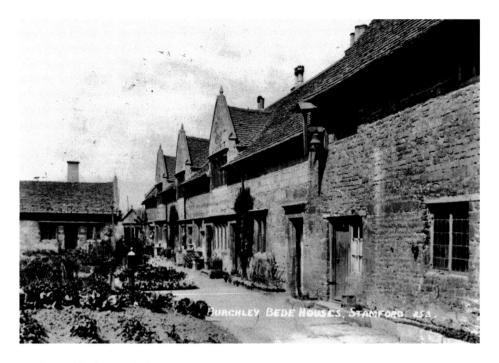

Lord Burghley's Hospital

Lord Burghley's Hospital occupies the site of the Hospital of St John the Baptist and St Thomas the Martyr which had been founded *c.* 1170-80. The site was purchased by William Cecil in 1549. However the present hospital was not formally constituted and endowed until 1597. The hospital was to house thirteen old men, one of whom was to be the warden. As can be seen by comparing the two photographs, very little has changed externally. However, in 1964/5 the rooms were completely re-arranged. The hospital now provides accommodation for married couples as well as single elderly men.

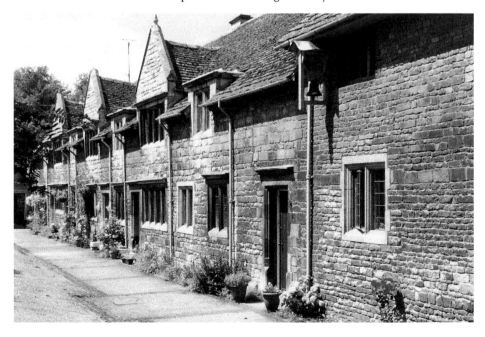

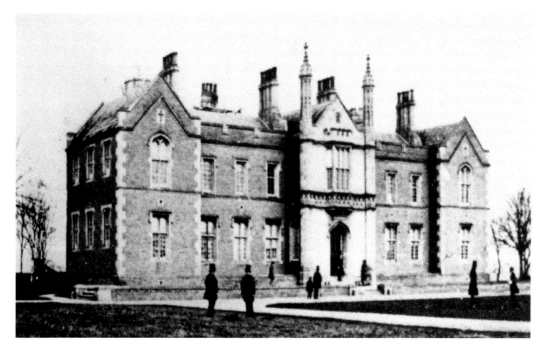

Stamford & Rutland Infirmary

Stamford & Rutland Infirmary was established from a bequest made by local surgeon Henry Fryer. The hospital was originally intended to accommodate twenty in-patients, and 'be capable of conveniently accommodating thirty-two if necessary'. It was opened for the reception of patients on 5 August 1828. Since then, the hospital has expanded considerably and has undergone many changes in its 181 years.

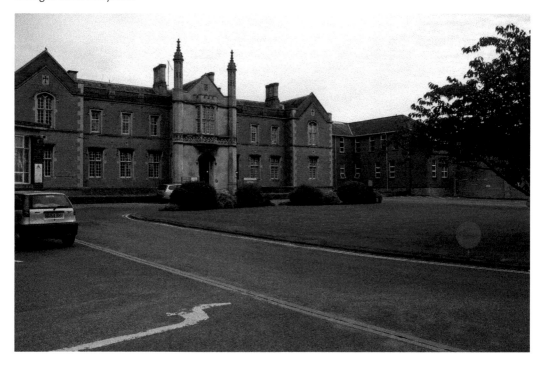

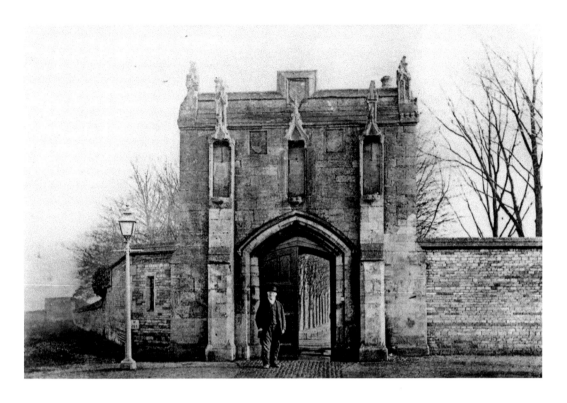

Infirmary Gate House

For many years this was known as Whitefriars Gate. However, it is now recognised that this is, in fact, the site of the Greyfriars. The Friars Minor, or Grey Friars were established here by 1230. In 1541 the site was given to the Duke of Suffolk, and was later bought by Sir William Cecil. It was here that Cecil entertained Queen Elizabeth in 1566. The site remained as part of the Cecil estate until it was sold to provide a site for the Infirmary. The older picture dates from 1890 and shows John Hisset, the hospital porter.

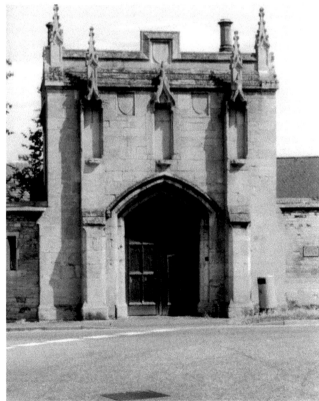

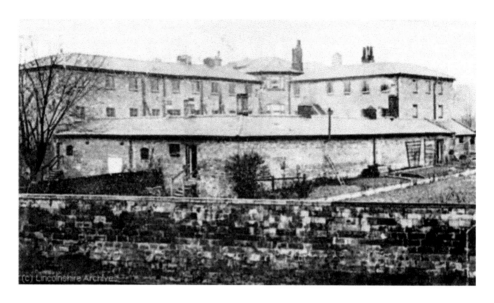

Barnark Road Workhouse

The 1834 Poor Law Amendment Act created the Stamford Poor Law Union with a total of thirty-seven parishes covering a large area of Rutland, Northamptonshire, the Soke of Peterborough, Kesteven and parts of Huntingdonshire. The new workhouse was built in Barnack Road and opened in 1837 having been designed to accommodate 300 poor people. However, the building was comparatively short lived as it was demolished in 1902.

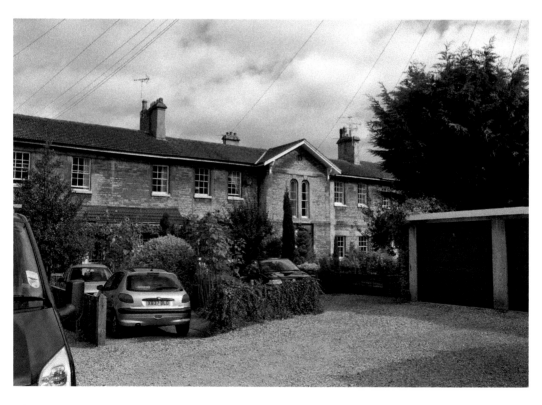

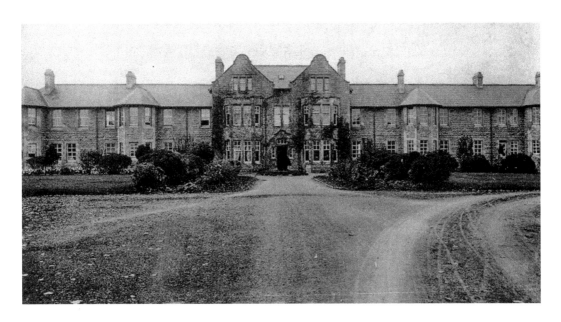

Bourne Road Workhouse

In 1899 the Poor Law Guardians took the decision to build a new workhouse on the Bourne Road. Completed in 1902, this new building could accommodate 175 inmates. After 1930 it became a Public Assistance Institution and in 1948 became part of the new National Health Service as St George's Hospital. It was demolished a few years ago to make way for retirement housing.

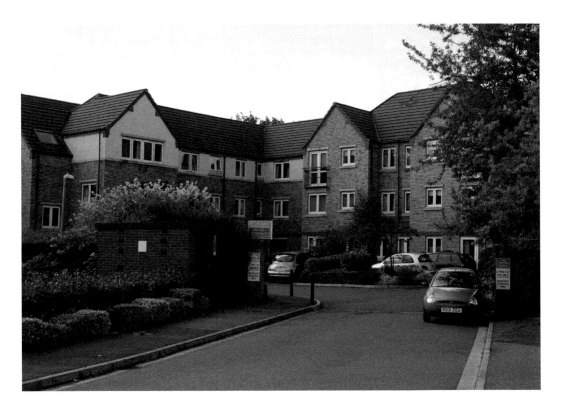

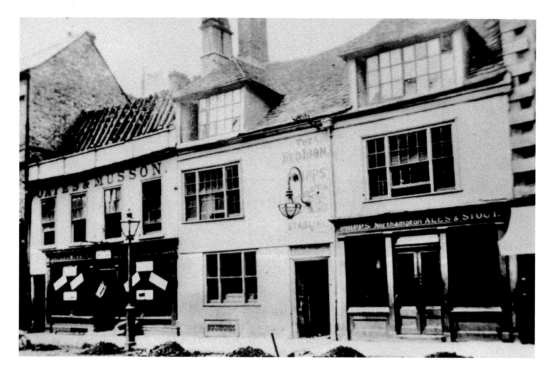

The Red Lion

The Red Lion pub formerly stood in High Street, and probably dates from the middle of the eighteenth century. However, the building itself is obviously much older as is evidenced by a surviving vaulted medieval undercroft. Next door to the Red Lion, at number twenty-three, was the store run by Oats and Musson. In 1904 both sites were cleared by Oats and Musson and a new department store built. In 1965 the building was almost completely destroyed by fire, only the façade remaining.

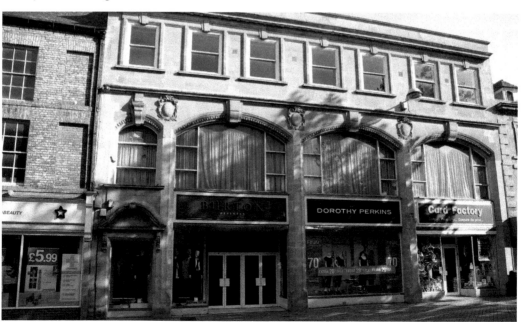

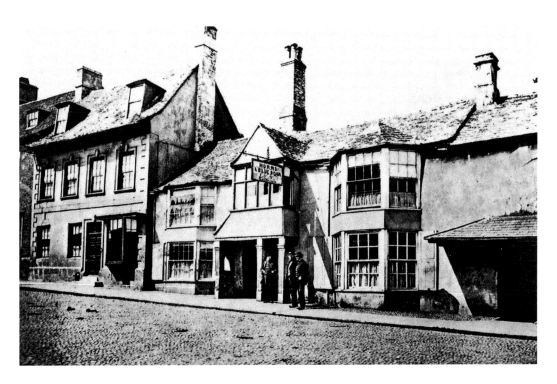

The Horns and Blue Boar

The Horns and Blue Boar was situated in that part of Broad Street known as the Beast Market. It is not clear when it first became a pub, but in 1717 it was known as the Buck Horns. On the extreme right of the photograph as be seen the Dolphin pub which was demolished in 1862. The Horns and Blue Boar was demolished in 1876.

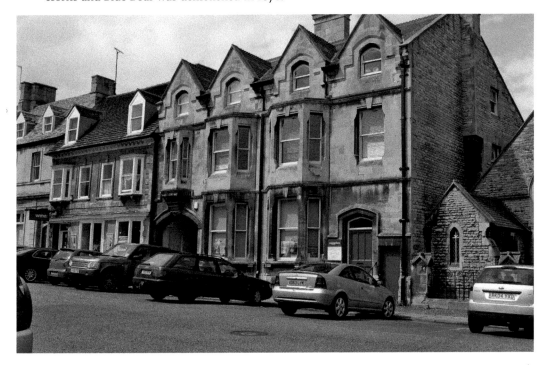

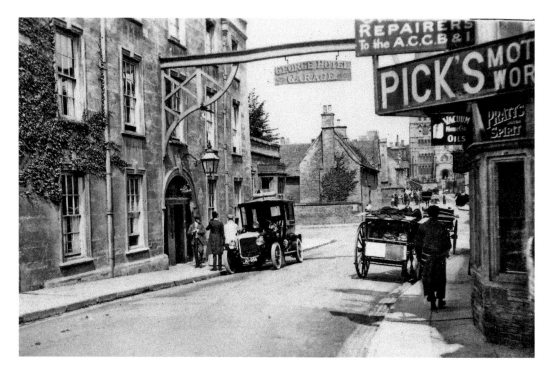

The George Hotel

The George Hotel was known to have been in existence before 1541. The earliest part of the present building is the east range which dates from about 1600. The building was refronted in 1724 by George Portwood for the Earl of Exeter. The above photograph was taken in about 1908. Pick's motor works can be seen on the right of the picture.

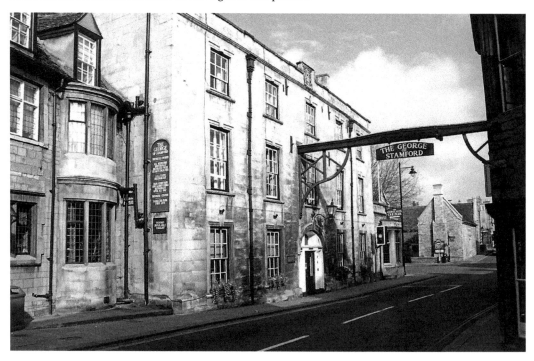

The Castle

Castle Street was a fairly narrow street which was widened in 1939/40. The Castle pub can be seen on the right and this was in existence from about 1854 through to 1959. On the opposite side can be seen the sign for another pub which was originally the Shepherd & Shepherdess and later became the Prince of Wales. The buildings on the left of the picture were demolished in the 1930s when the road was widened and the London Inn built.

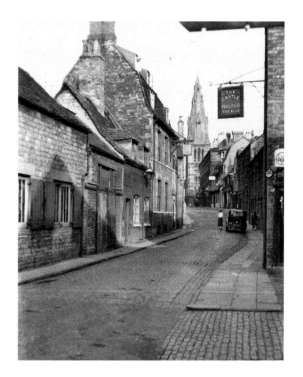

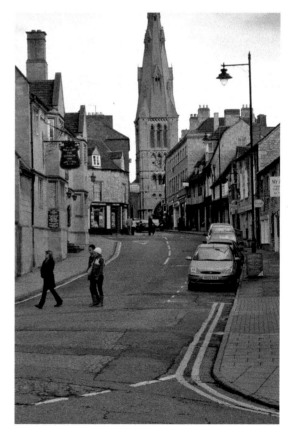

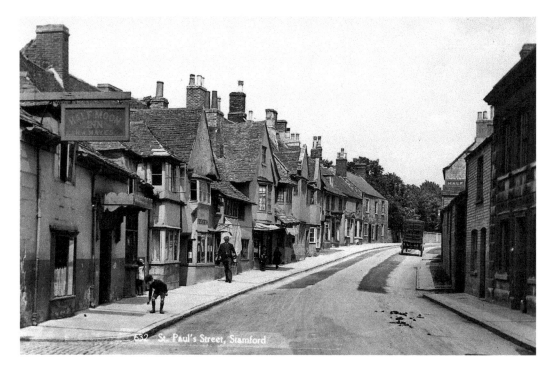

The Half Moon

The Half Moon is first mentioned as a pub in 1744. The earlier building was almost certainly medieval in origin. The building was demolished in 1938 by its owners, Phillips Brewery and a new pub built to a design by local architect H. E. Traylen. Given that it was rebuilt at about the same time as the London Inn, there are close stylistic similarities between the two. It is now a Chinese restaurant known as the Beijing Rendezvous.

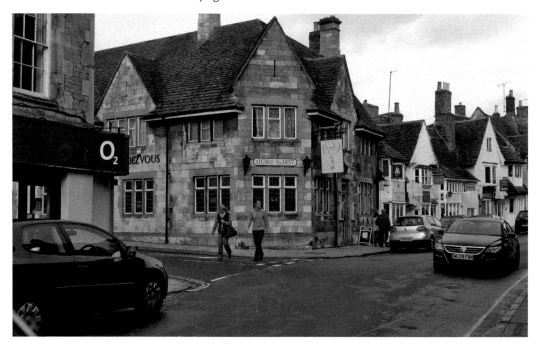

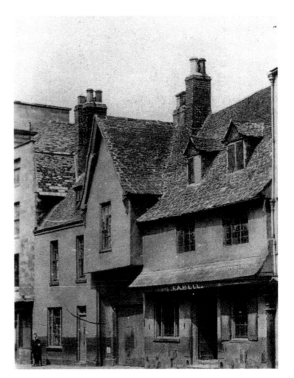

The Vaults

The Vaults in St Mary's Street was established in about 1722 as the Eagle and Child. The first reference to it as the Vaults appears in 1818. The site is clearly an ancient one and, if one looks carefully, traces of most building periods from the late Middle Ages onwards can be seen.

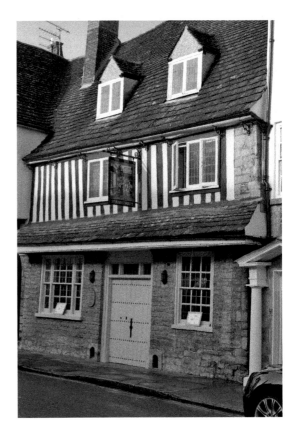

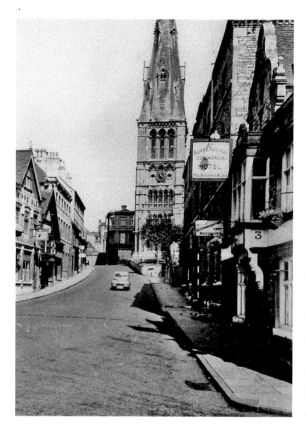

The Boat & Railway

In this photograph the Boat & Railway on St Mary's Hill can clearly be seen. Originally called the Boat, the inn dates from 1779. It was first referred to as the Boat & Railway in about 1906. It closed in 1962. Further up the hill on the opposite side can be seen the Queens Head pub which closed in about 1968.

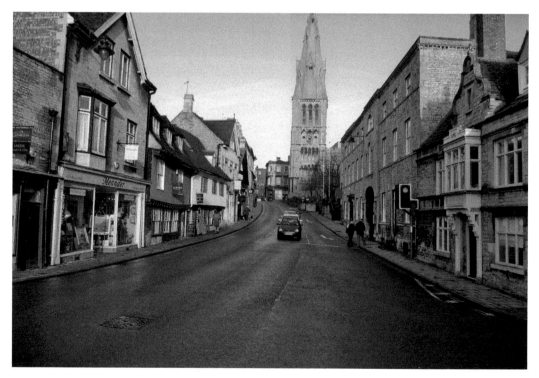

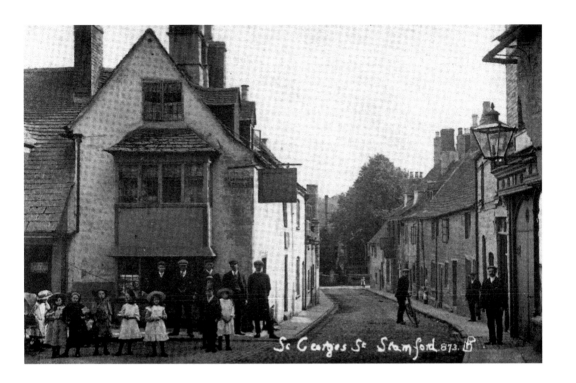

Forresters Arms

This building standing at the corner of St George's Street and St Leonard's Street, appears to be seventeenth century in origin. According to the late John Chandler's list it first became a pub in 1846 and was then known as the Talbot. In 1879 it became the Foresters' Arms and traded under that name until 1909 when it closed. The original building still survives but has been radically altered. In the 1920s the building was purchased by John Connington, a pork butcher and pie maker. In recent years it was taken over as the Ark Bookshop before becoming C. L. C. (Stamford) Booksellers.

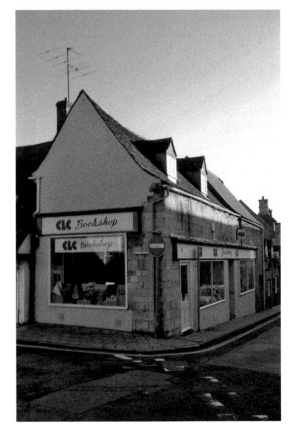

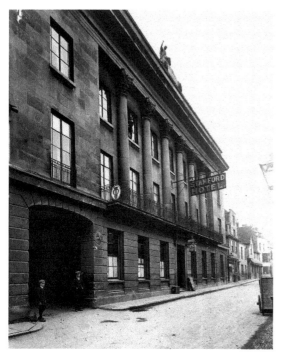

The Stamford Hotel

The Stamford Hotel was built by Sir Gerard Noel of Exton as part of his campaign to attract electoral support against Lord Exeter's political monopoly. The building, which incorporates parts of the Black Bull Inn, was designed by J. L. Bond of London and work began in 1810. Work on the building ceased after Noel's election defeat in 1812 and it remained empty until 1825 when it was bought by Thomas Standwell and re-opened as a hotel. Following a chequered career as a hotel it closed and stood empty for some time. In 1983 it became the Stamford Walk shopping centre.

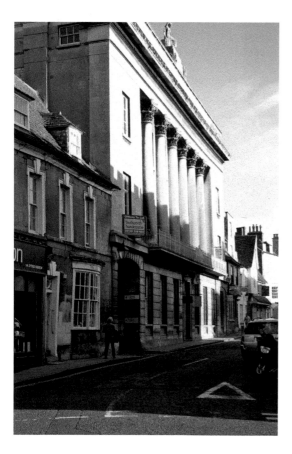

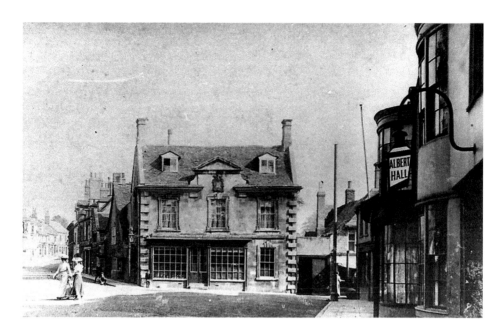

Co-op Corner

This area is generally referred to as Co-op Corner. The building in the centre of the old photograph was erected sometime in the mid eighteenth century and the shop front was added in the nineteenth century. The Peterborough Cooperative Society purchased the site in 1901 along with a number of other properties in the immediate area. In 1909 the building was demolished but the decision was taken to rebuild it in a style similar to the original. The property has recently been developed by Marks & Spencer.

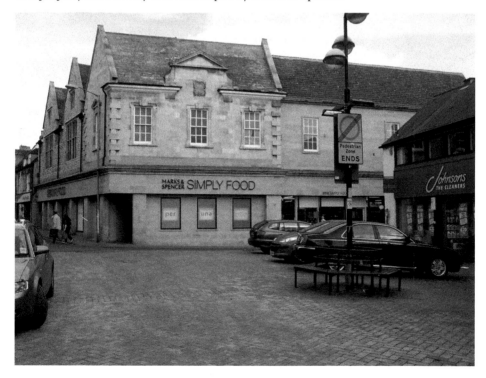

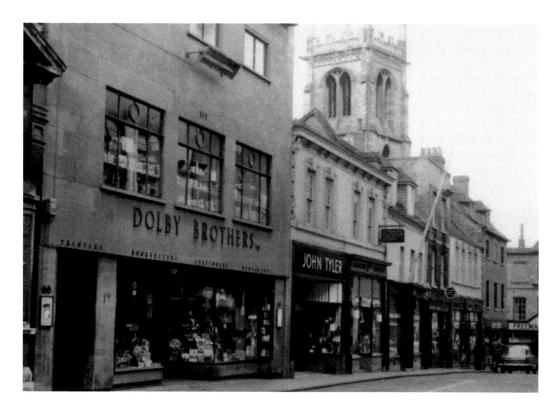

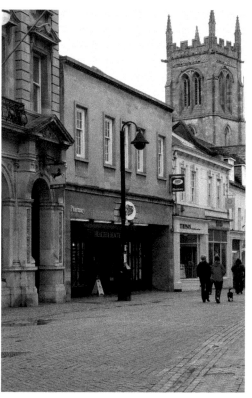

Dolby's Shop

Dolby's shop formerly stood at 66 & 67 High Street on the site now occupied by Boots. They were well known in the area as printers and stationers, and, for many years, printed the annual *Dolby's Almanack and Directory*. The shop was built in 1935 to a design by Harold Kelham. This ugly and unsympathetic building was finally demolished in about 1968.

21 High Street

This shop at 21 High Street was built as a house in 1732 but the ground floor had become a shop by 1804. It is possible that this was the shop that Richard Knight traded from as a draper. He died in 1857 and the property was acquired by Pinney & Son, who were clock and watch makers, jewellers and silversmiths. They continued to trade here until the business moved to Red Lion Square in about 1950. The property was then acquired by Westmorelands the TV dealers. Since then the property has changed hands many times and has recently become a coffee shop.

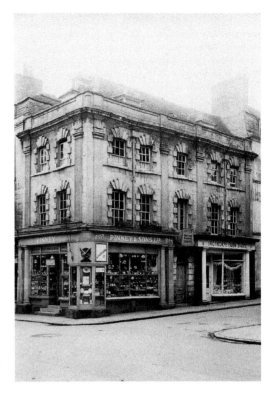

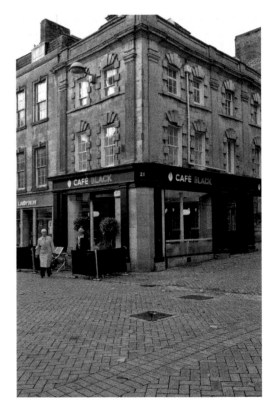

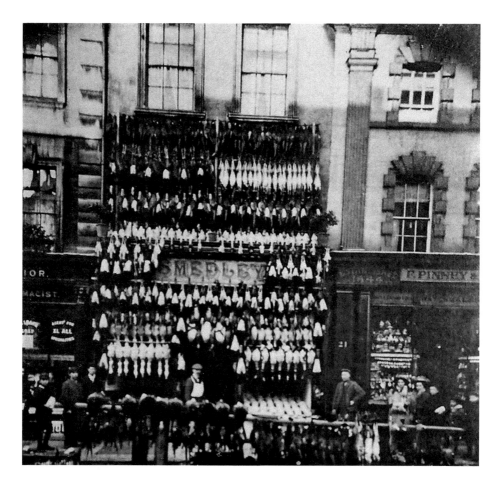

Smedley's, High Street
Albert Edward Smedley, fishmonger, game, poultry & venison dealer traded at this High Street shop here from about 1900 until the 1920s. This magnificent display was photographed in about 1914. Such a display would certainly attract officialdom on in the twenty-first century.

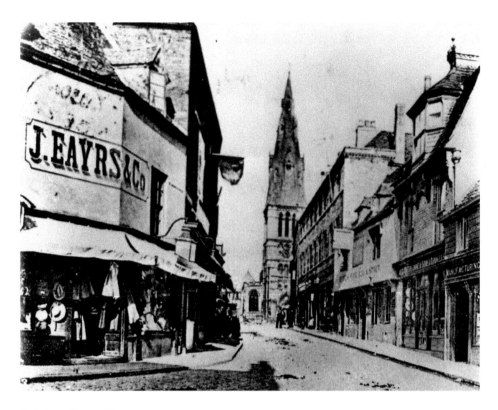

St John's Street Corner

This corner of St John's Street and St Mary's Street not only marks the south-western limit of the original Danish borough but was, according the *Stamford Mercury,* a notorious accident black-spot in coaching days.

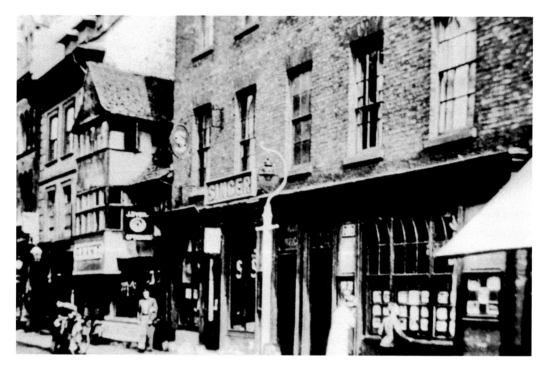

60 High Street

Grant's butchers stood at 60 High Street. It was a timber framed building of uncertain date, but probably sixteenth century. In 1936 the building was dismantled and removed to the Castle Museum in York where it became part of the Kirkgate Victorian Street. The building erected in its place was for many years the local Woolworths store.

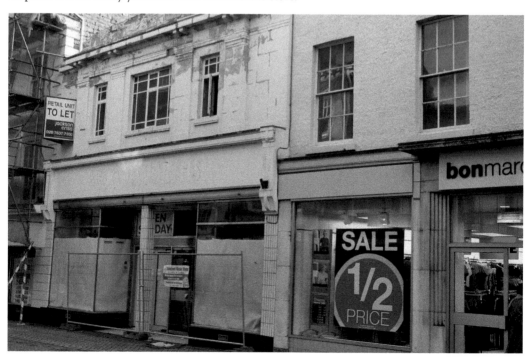

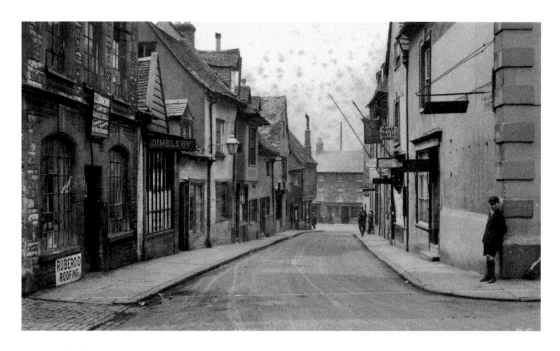

Red Lion Street

Red Lion Street links Broad Street with Red Lion Square and was named after the nearby Red Lion Inn. The street was created when the west end of Broad Street was infilled, and appears to have always had a commercial function. The Lord Nelson Inn once stood at number 3. The building on the extreme left of the picture still exists, but Dimbleby's shop has long since been demolished.

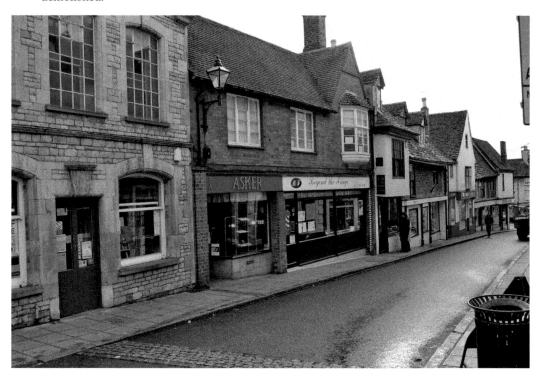

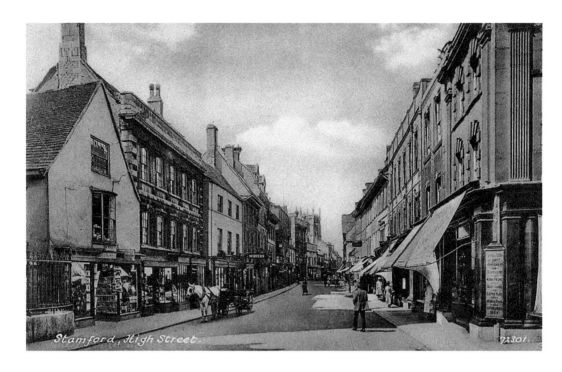

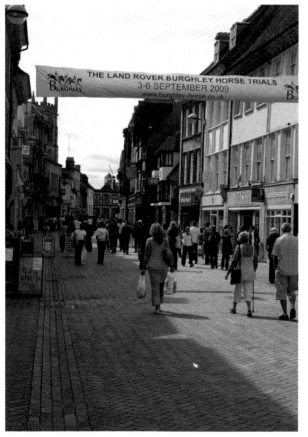

The Butcher's Shambles and Fish Market

The High Street was the main axial street of the Danish Borough. It has always been an important commercial street. The butcher's shambles and the fish market were once held in the wide space in front of St Michael's church. This general picture of the High Street gives a good idea of what the street was like in a quieter age. Note the blinds over the shop windows which were a common feature for many years.

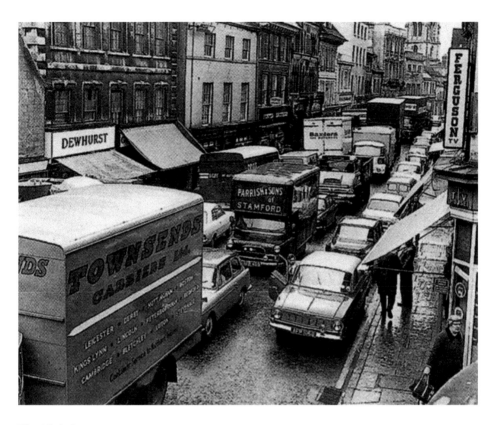

The High Street

At this distance, it is difficult to remember what High Street was like before it became a pedestrian precinct. However, this picture gives some idea of the congestion that traffic in the street often caused.

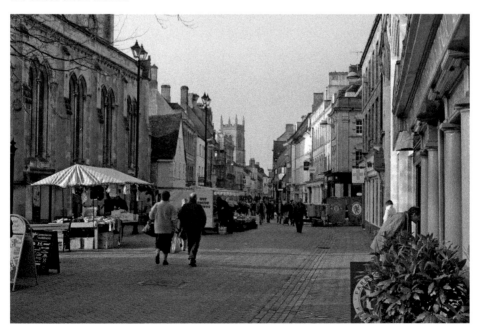

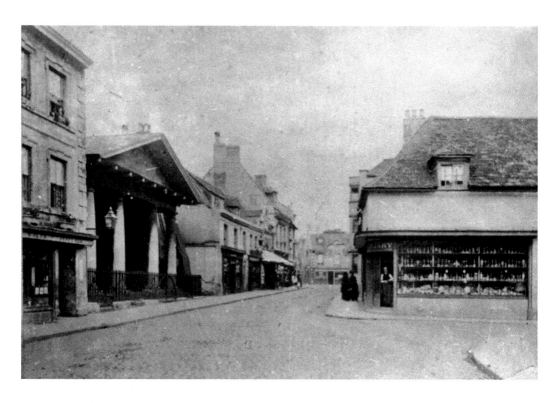

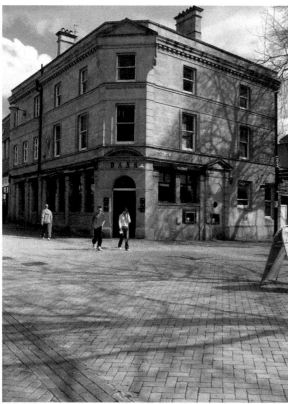

Robert Crosby

In 1850 Robert Crosby opened his business at the corner of Maiden Lane and High Street, dealing in china, glass and earthenware. The building seen here was demolished in 1890 and a new building erected for Henry Knott, a grocer. The property was acquired by the National Provincial Bank (later the National Westminster) in 1925.

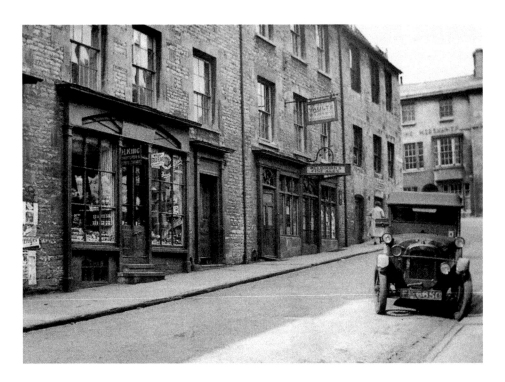

Ironmonger Street

Ironmonger Street was so named because of the predominance of ironmongers in the area. The whole of the east side of the street was, at one time, taken up by the Blue Bell Inn. This inn was established by 1595, but gradually declined in size throughout the seventeenth century. To judge by the car, this picture was probably taken in the 1920s or 1930s. The building with the sign outside is the Vaults and the lower sign is advertising Melbourn's fine ales. Unfortunately, the rather nice nineteenth century shop front has been removed.

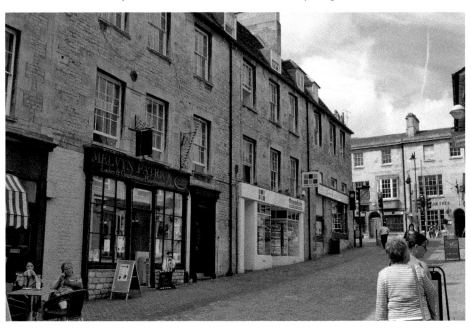

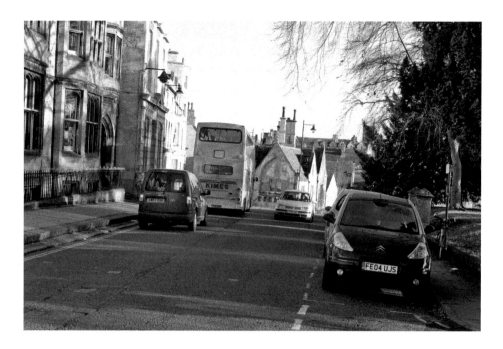

SS Simon and Jude Fair

Prior to 1791, the sheep fair was held at the top of Barn Hill. However, in that year the market was moved to the area we now know as Sheepmarket. During the SS Simon and Jude Fair (November) stalls were erected in Castle Dyke, Sheepmarket and up to Castle Hill. Until 1820 the fair was only held on one day (8th) but in that year it was split into two with the 8th being for horses and sheep and the 9th for beasts. While the market has long gone, the proximity of the bus station makes this an extremely busy road junction.

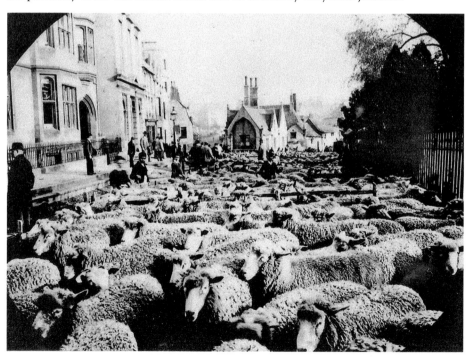

Sheepmarket

Another view of the SS Simon and Jude Fair. This and the previous photograph give some idea of the scale of the operation and the probable state of the streets when the fair had finished. Sheepmarket has been the subject of some contentious debt in recent years due to the developments carried out by Stamford Vision. The area in front of the Golden Fleece is now dominated by a sculpture representative of the Eleanor Cross which was commissioned by Lincolnshire County Council and created by the Nottingham artist Wolfgang Buttress.

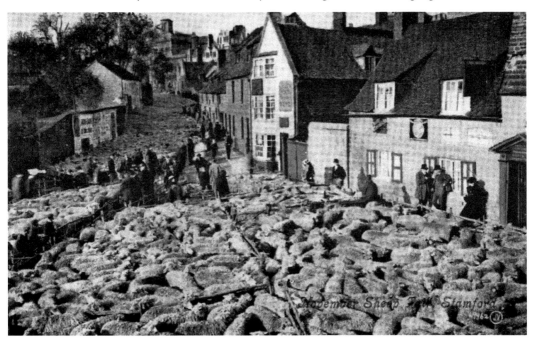

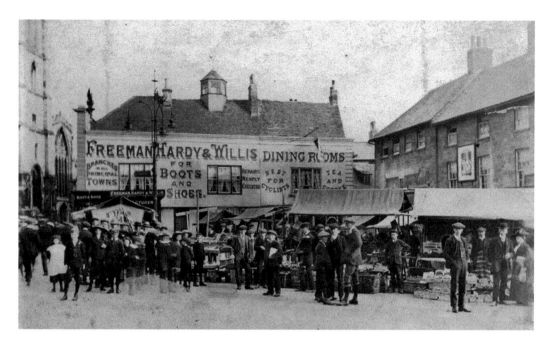

Red Lion Square

Red Lion Square has always been an important market area, and in the mid-nineteenth century there was a scheme to erect a free-standing butter market in the square. Opposition from local shopkeepers resulted in a more modest building which was built on the site of the Horseshoe public house. For many years the square not only formed part of the A1 through Stamford, but the south-western corner was given over to a car park. However, recent developments have provided the opportunity yet again for markets and other events to be held here.

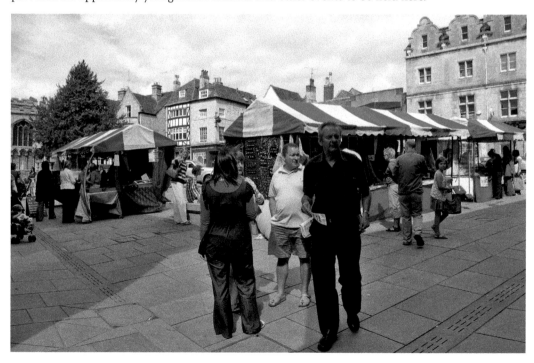

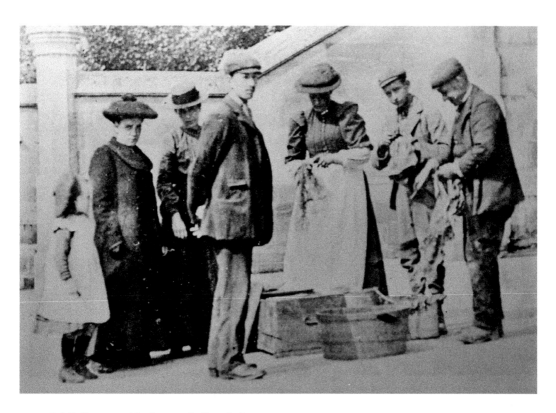

Eel Sellers outside Browne's Hospital

This photograph dates from the early 1920s and shows Mr & Mrs Robinson who came regularly from Market Deeping to sell eels in Broad Street. There are no eels in the modern picture, but the tradition of selling fresh fish in the market continues.

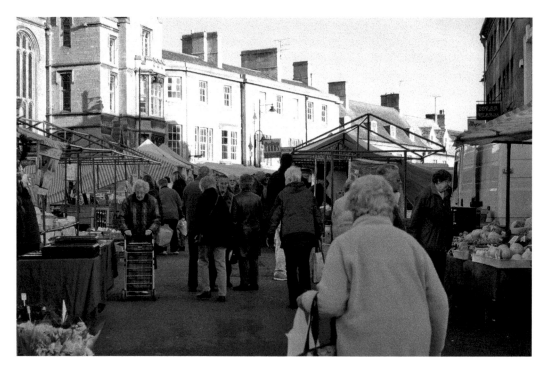

Broad Street

The very width of Broad Street sets it apart as a market area. The east end of the street was known as the Haymarket; the beast market (seen here) was held in the central part of the street until 1890 and the corn market was in front of Browne's Hospital. The street is still used for the weekly Friday market.

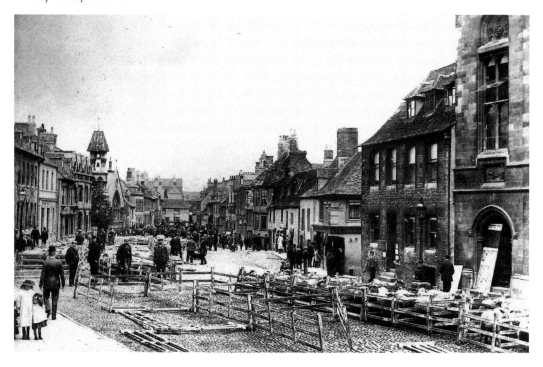

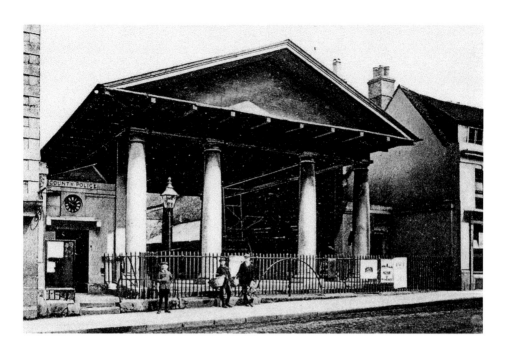

Portico

This site was purchased by Stamford Corporation in 1801 as a site for the new butchers' shambles. The portico was opened in 1808 to a design by William D. Legg. As can be seen from the photograph, this was an open portico supported on Tuscan columns. The butter market was held under the portico, and behind was the fish market and fifty-three butchers' stalls. The two small buildings at either side housed the police station and the beadle's house. The sides of the portico were later filled in and in 1906 it was opened as a library. For many years, the town's museum was situated on the mezzanine floor before it moved to the old Technical Instruction School in Broad Street in 1980.

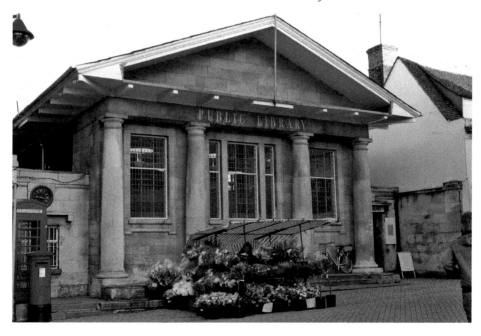

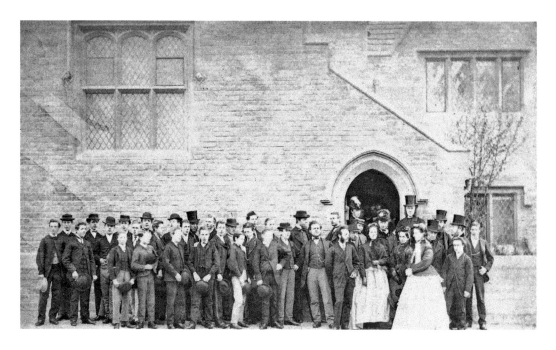

St Martin's School

This photograph shows the staff and pupils outside St Martin's school. The gentleman on the extreme right in the top hat is Mr Joseph Phillips the brewer. The gentleman in the soft hat to the left of the door is Mr Knight the headmaster, so this would date the photograph after 1868. St Martin's school closed some years ago. However, the building is still used for educational purposes as it is now the music department of Stamford High School.

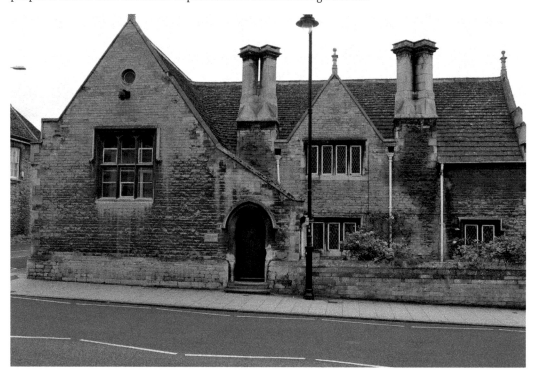

St Michael's School

St Michael's school was built at a cost of £1,100 and was opened in September 1860. For want of proper premises, the school had been held for a time in the back room of the Dolphin pub in Broad Street. The school had closed by 1959 when it was taken over as part of an enlarged Bluecoat school, and remained as such until the early 1970s. After standing empty for some time it was demolished to make way for new housing.

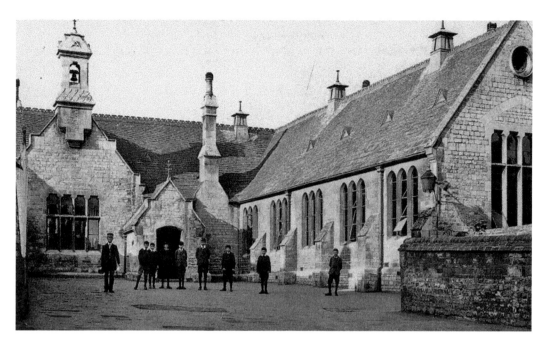

The Bluecoat School

The Bluecoat School had been founded in 1704 and was housed in two other buildings before this new building was opened on St Peter's Hill in 1838. The school occupied this site and a number of other locations in the town, including the old St Michael's school, until the present Bluecoat school was built in Green Lane in 1969. The St Peter's Hill building is now the Stamford Masonic Centre.

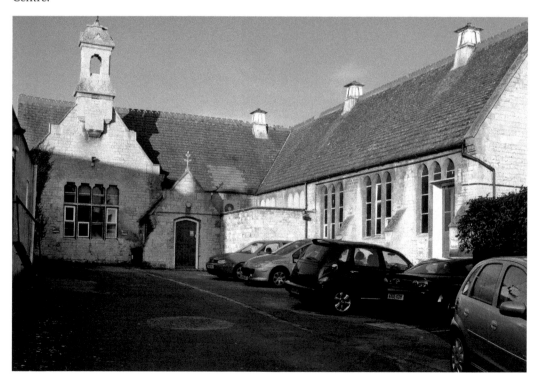

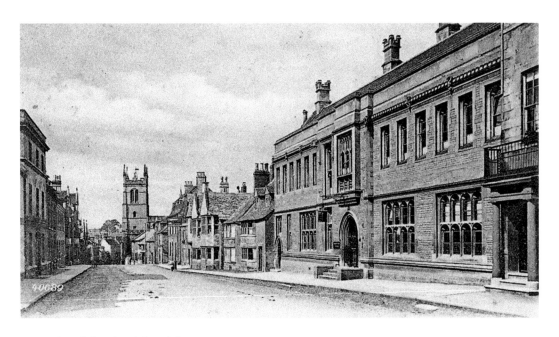

The High School for Girls

The High School for Girls was founded in 1876 under a scheme drawn up by the Endowed School Commissioners, and opened in 1877. The building was designed by local architect Edward Browning. Since the school first opened, many of the buildings to the south have also been taken over for school use.

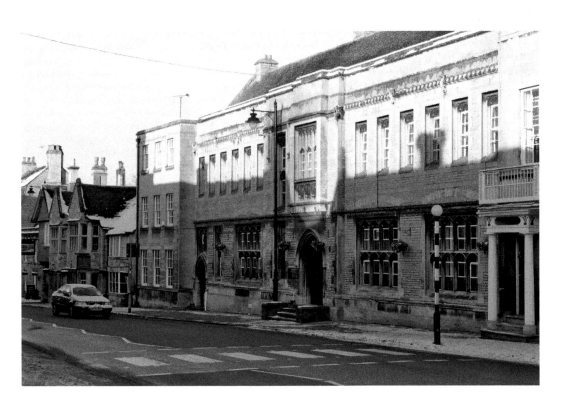

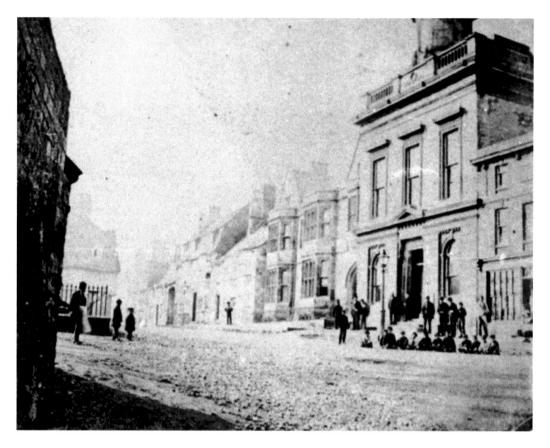

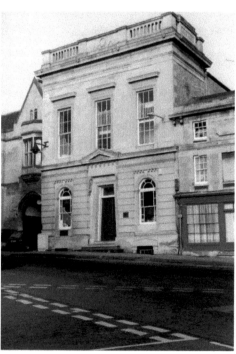

The Stamford Scientific and Literary Institute
The Stamford Scientific and Literary Institute
began life in Broad Street in 1838. However,
it outgrew its original premises and local
architect Bryan Browning was commissioned
to design a new building. Browning came up
with an interesting Greco/Egyptian design,
which was built in 1842 on the site of the
Castle inn. The institute housed a substantial
library and had a museum as well as lectures
halls and a concert hall. An octagonal
observatory with a camera obscura was built
on the roof, although this was removed in
1910. In recent years the building has been the
home of the YMCA, but now houses Castle
Hill International Language Centre.

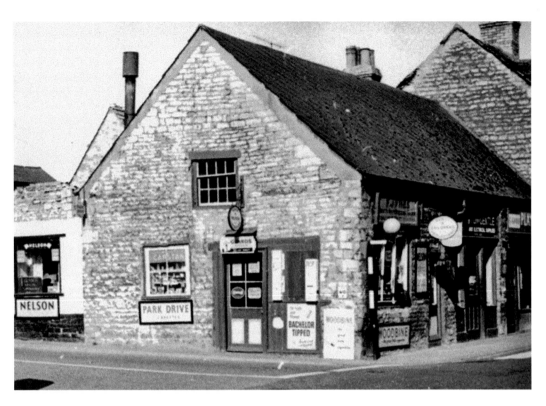

Felix Vines

This photograph shows Felix Vines hairdressers on the corner of Scotgate and West Street. This, and the adjacent shops were in poor condition and were demolished some years ago to make way for a modern development. The north-west corner site is now occupied by C. J. Carpets & Lighting.

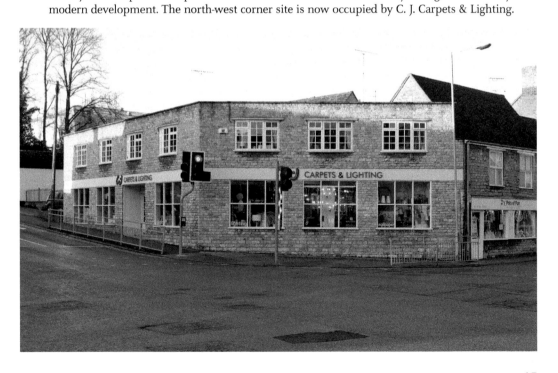

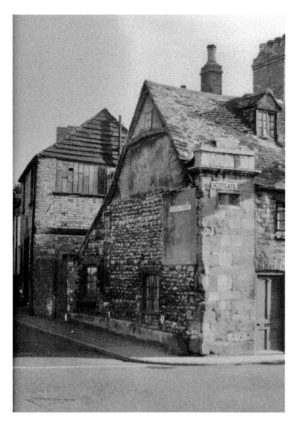

Scotgate

Until modern times Scotgate was a relatively poor area of the town. This can clearly be seen by these buildings at the corner of Scotgate and North Street. As with the buildings in the previous photograph, they were eventually demolished to make way for a modern development.

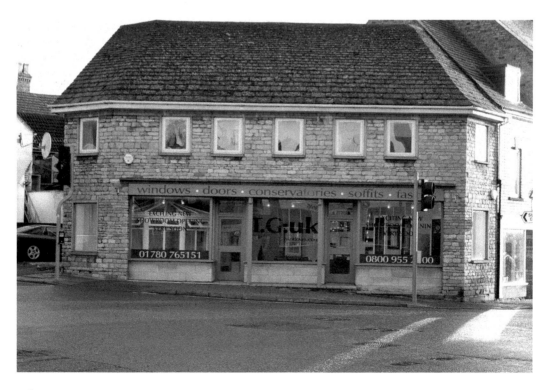

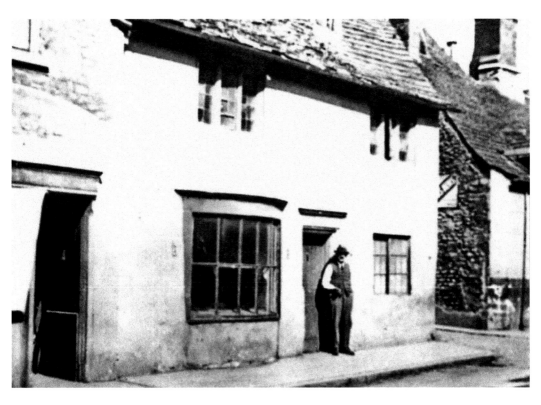

5 St Paul's Street

This small seventeenth century building was 5 St Paul's Street. It was demolished in 1923 to widen the entrance to Star Lane.

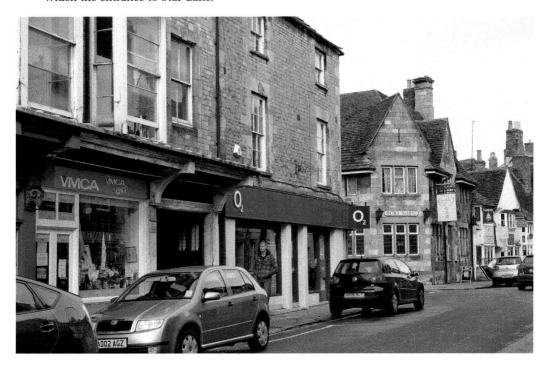

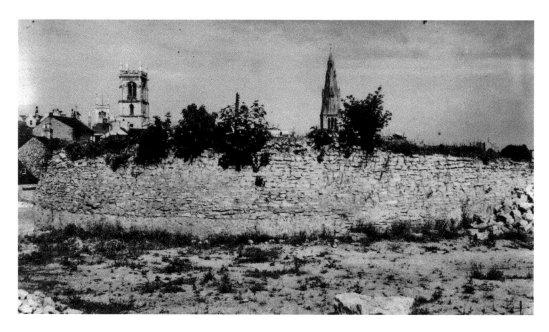

Castle Keep Remains

The photograph shows the remains of the castle keep. This was excavated and the site levelled in 1933. Initially the site became a car park, but was later converted to a bus station. In the 1980s, the bailey area of the castle was further excavated before the development of a modern housing complex on the site.

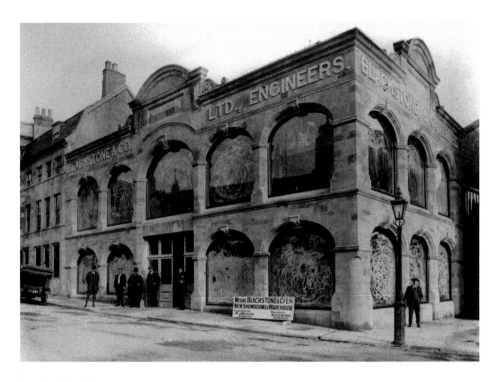

Cambridge Cinema Company

Blackstones originally opened an office in an existing building on this site towards the end of the nineteenth century. The building pictured dates from about 1913. This was sold to the Cambridge Cinema Company in 1925 and it opened as a cinema in 1926. The building was completely destroyed by fire in March 1937. The new cinema, built to a design by George Coles, is an art deco design which contrasts oddly with other buildings in the area. The new cinema opened its doors in February 1938. It closed as a cinema in 1989 and became, variously, a bingo hall and a night club.

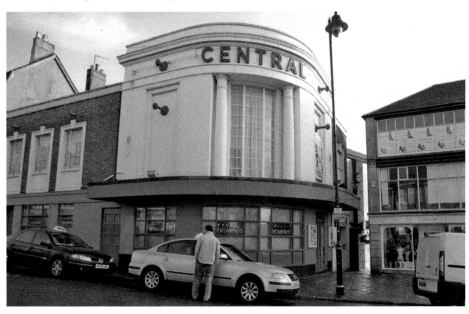

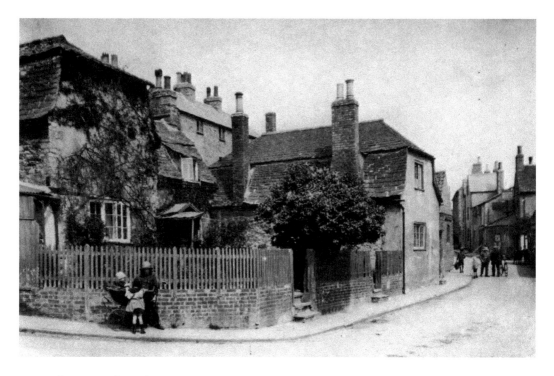

Recreation Ground Road

This photograph has been taken looking along East Street from the corner of Recreation Ground Road. All of the buildings in the original photographs were scheduled for demolition in 1936, and for many years the site remained vacant until the Salvation Army built their Citadel on it in 1973. The Salvation Army vacated the site in 2006 and the site again remained vacant until being cleared towards the end of 2009 for work to begin on a new housing development.

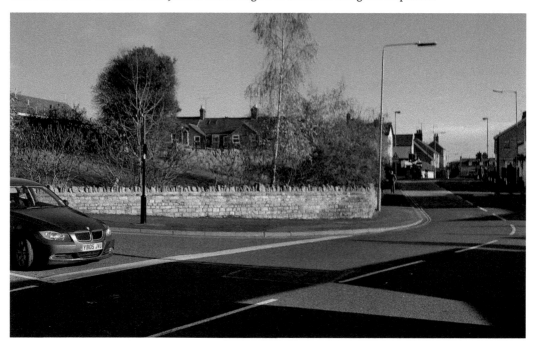

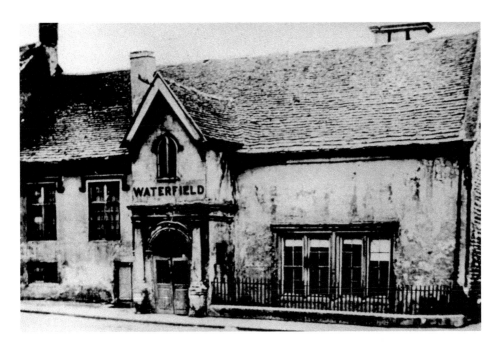

Waterfield House

This house was situated at the corner of Castle Dyke and Sheepmarket, and was occupied for many years by the Waterfield family of saddlers. The position of the windows on this house suggest that it may have been a stone built medieval house, probably with an open hall at the east end. The house was demolished in 1885. The site was later developed as stabling and stores for the Young family. In later years the site was taken over by Forsyth and Ferrier as a garage and motor accessories shop. The shop is now occupied by Colin Bell and the rest of the site is now occupied by the offices of the *Stamford Mercury*.

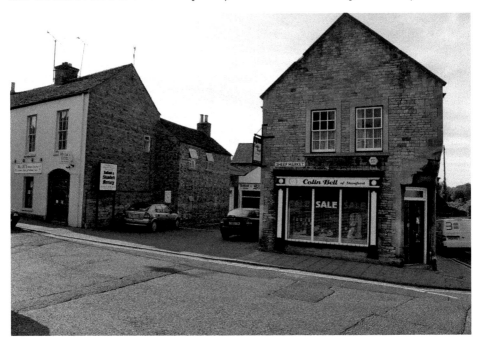

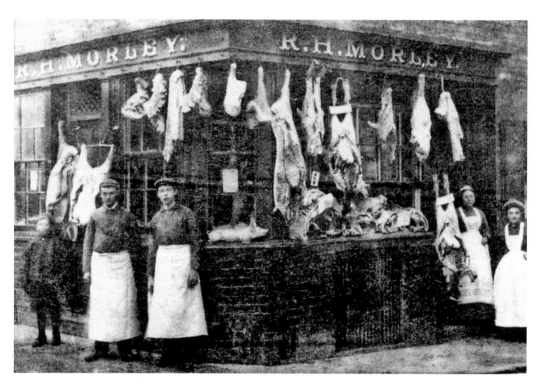

Water Street
Morley's Butchers stood at the end of Water Street, adjacent to the Anchor Inn. It was demolished in the early 1970s to widen the entrance into Water Street.

51 High Street

51 High Street was demolished in 1966 a year before the creation of the Conservation Area. The house was a medieval timber-framed building with seventeenth and eighteenth century additions. It was for a time the Windmill Inn. It was in this building that a tablet to Blanche Lady Wake, daughter of the Duke of Lancaster, was found. She died in 1390 and was buried in the Greyfriary. The stone is now preserved in St George's church. The buildings that replaced it have done nothing to enhance the streetscape.

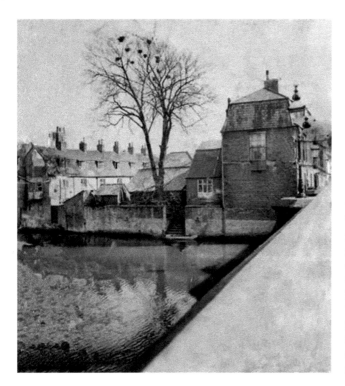

The Anchor

This picture has been included not so much for the Anchor itself, although a number of changes can be noted; but to show the row of houses behind it in Water Street. These were demolished and for a time a garage was on that site. The garage was later demolished to make way for new houses.

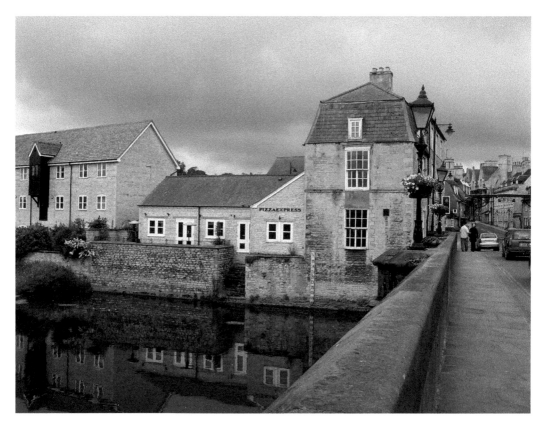

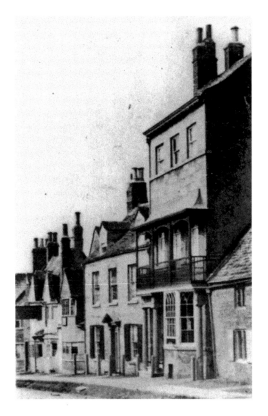

30 High Street, St Martin's

A photograph of 30 High Street, St Martin's taken in about 1875. The canopy of the first floor balcony has been removed, but otherwise the exterior of the building is much the same. The house now forms part of Stamford High School and, as can be seen from the second photo a number of building were demolished to make way for the new school building in 1877. The pub on the extreme left of the earlier picture is the Daniel Lambert.

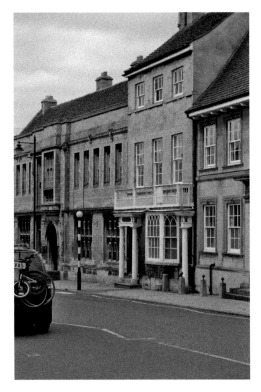

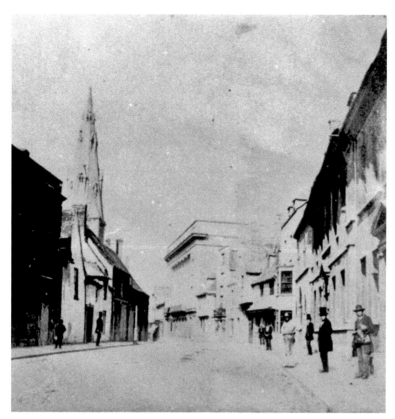

St Mary's Street
This photograph of St Mary's Street was taken in about 1860. Cars now dominate the scene, but it is interesting to note that there have been few changes otherwise.

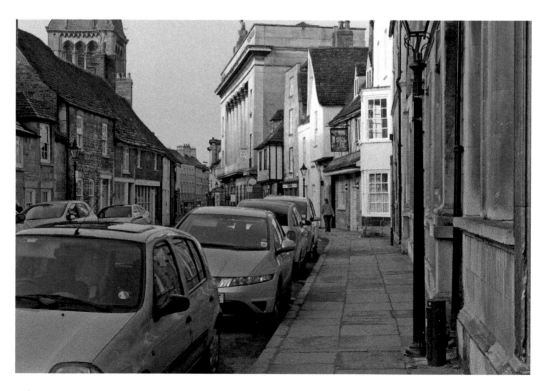

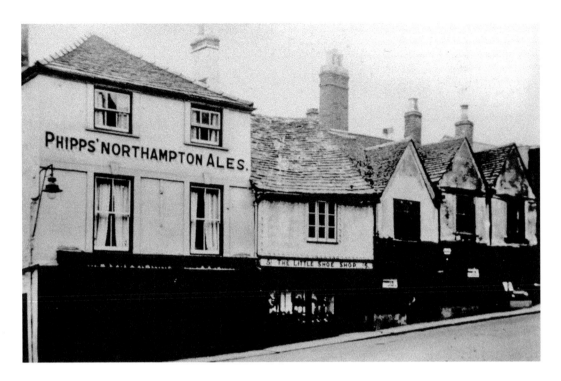

St John's Street

This photograph probably dates from the 1920s. The pub on the left of the picture is the London Inn which had been opened in 1868. All of these buildings were demolished in 1939-40 as part of a road widening scheme. The London Inn was rebuilt at the same time. At the time the second picture was taken, the inn had closed, and its future was uncertain.

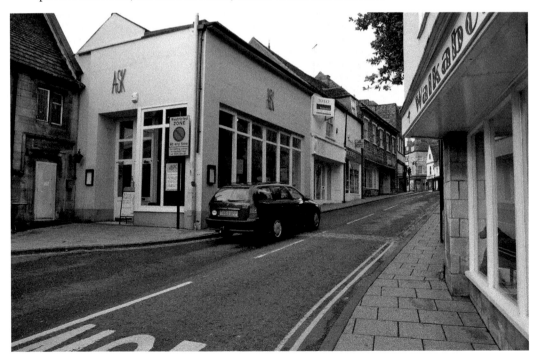

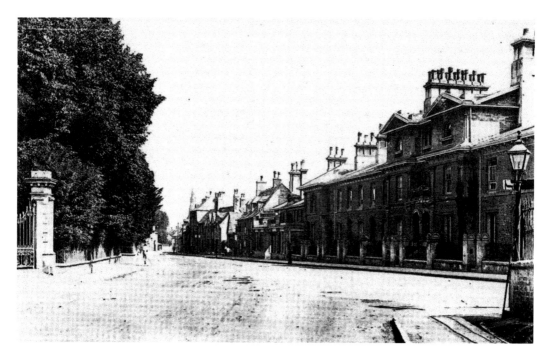

Scotgate

Scotgate was a relatively poor area of the town, although there were some improvements at the north end when Richard Newcombe created Rock House (1824) and Rock Terrace (1841). In the earlier photograph can be seen the mature trees in Rock House Gardens with Rock Terrace opposite. Rock House is now used as offices, and the gardens have long gone to be replaced by a petrol station.

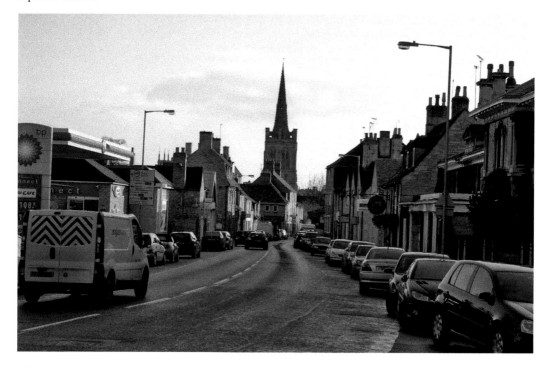

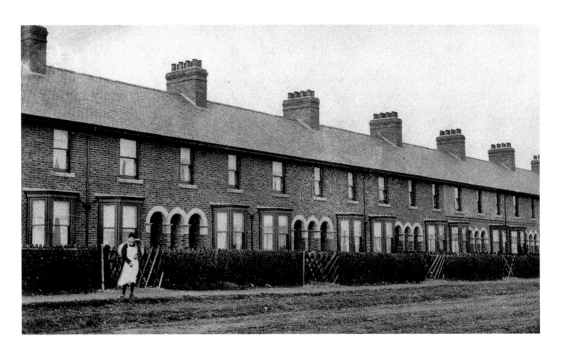

Bread and Jam Terrace

This photograph appears to have been taken not long after these houses in Ryhall Road were built. The houses which were known by locals as 'Bread and Jam Terrace' were built between the present Drift Road and Lincoln Road. There is a view that they were built to house the employees of Blackstone's factory. However, there is no evidence to verify this. At the time these houses were built this was known as Bourne Road.

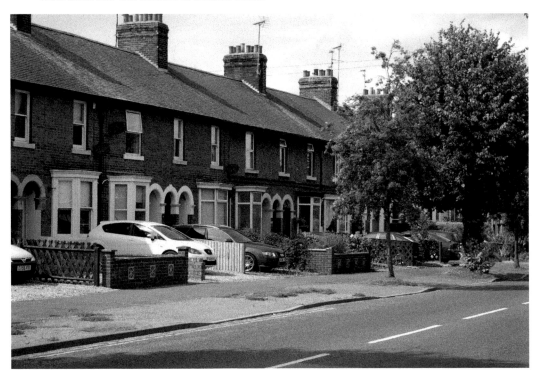

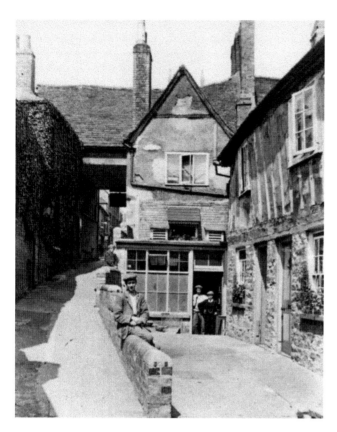

Brooke's Court
Until the second half of the
twentieth century, Stamford
had a large number of courts
and some other areas of quite
poor housing. The area between
Castle Street and the river
contained some of the worst
slums in Stamford, of which
Brooke's Court was but one.
Most had been demolished by
the late 1950s and early '60s,
but parts of them still survive.
Brooke's Court is also known as
Olde Barn Passage after the Ye
Old Barn Restaurant which was
opened there in the 1950s.

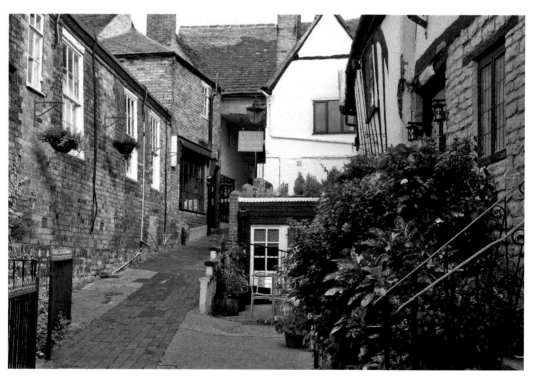

St Georges Street

St Georges Street probably delineates the eastern boundary of the original Danish borough. As can be seen from the earlier picture, the area was quite poor, and contained at least three courts and a number of small houses similar to No 11, pictured here. The modern Georgian-style house on the right of the modern picture provides an interesting composition.

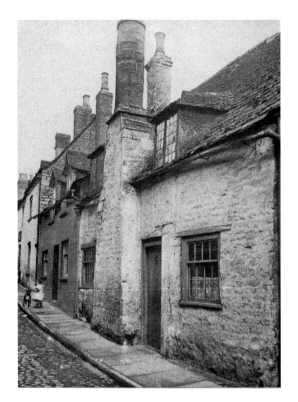

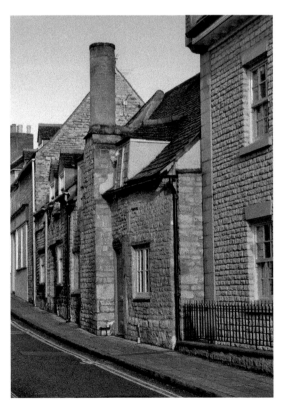

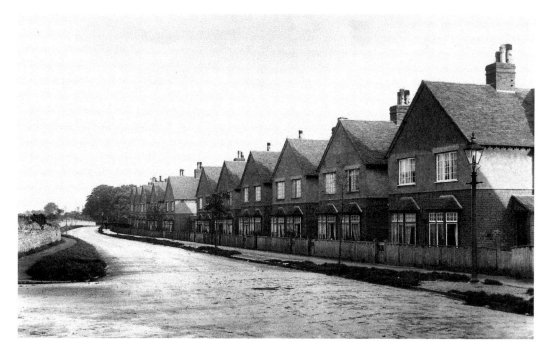

Priory Road and Gardens

Priory Road was developed in the early 1920s, at a time when car ownership was the exception rather than the rule; hence the absence of garages or driveways. For many years the area opposite the houses was given over to allotments. However, these have now disappeared under Priory Gardens housing development.

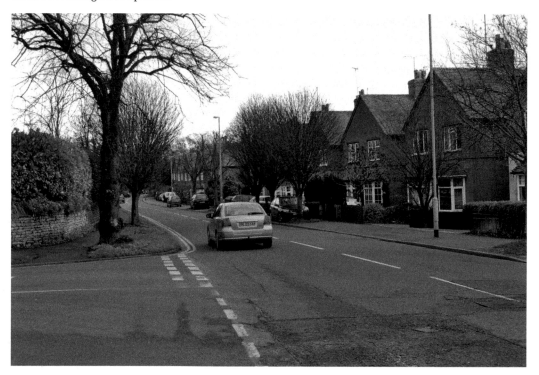

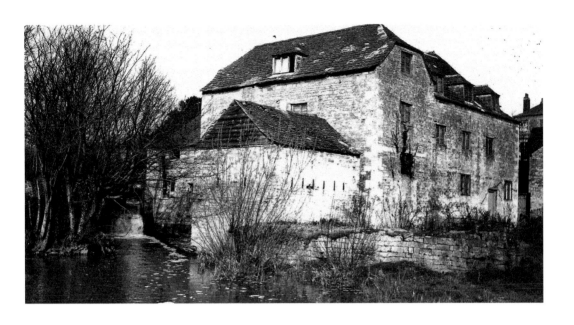

King's Mill

There is a mill mentioned in the Domesday survey which was probably the forerunner of the one on this site. The present building, which was once known as North Mill was built about 1640, and was owned by Lord Exeter. It ceased as a working mill many years ago and is now the King's Mill Centre, a facility run by Lincolnshire County Council.

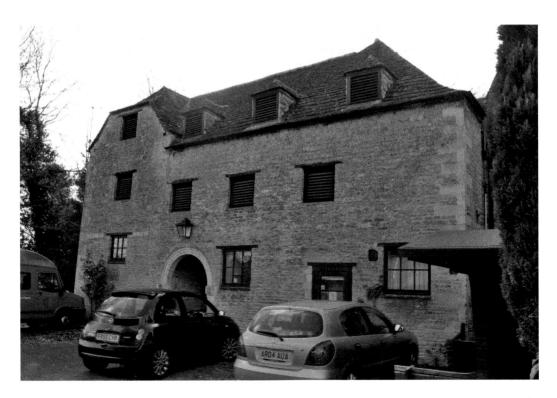

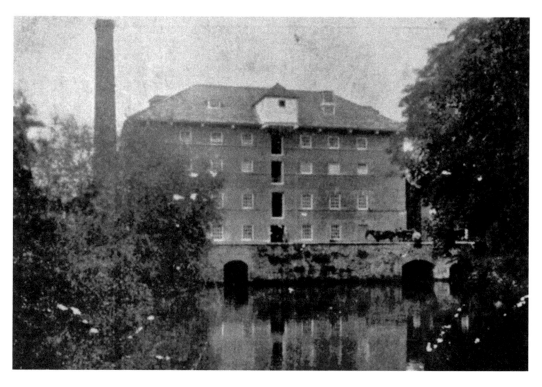

Newstead Mill
Newstead Mill stands about a mile to the east of Stamford, and stands on the river Gwash. Like King's Mill it ceased to be a working mill some years ago, and has now been converted to apartments.

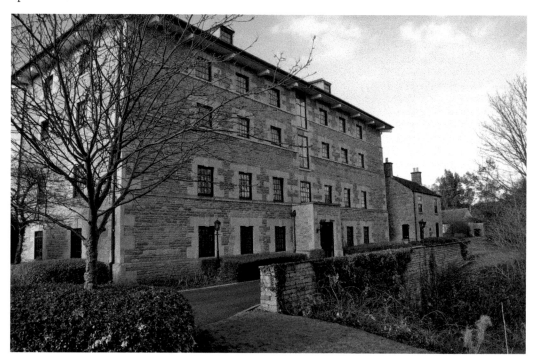

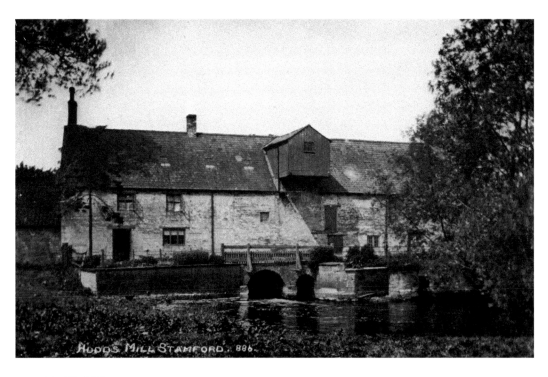

Hudd's Mill

Hudd's Mill is seventeenth century in origin and was owned by Stamford Corporation. It remained in use as a mill until about 1900. It is now in private ownership.

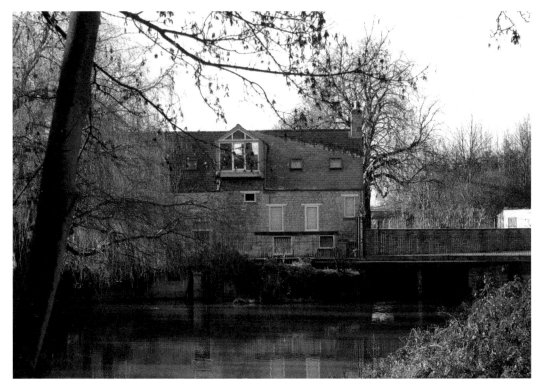

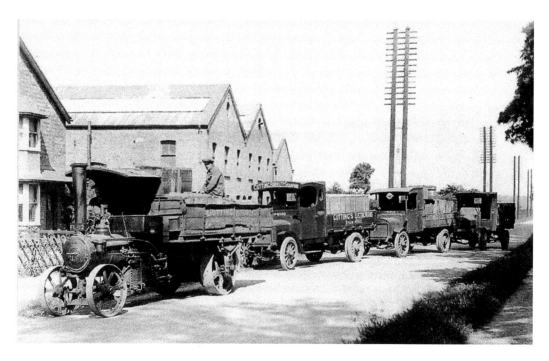

Barnack Road

The eastern end of Barnack Road has been associated with the electrical engineering industry for some years. In the early photograph we can see lorries lined up outside Cuttings factory which opened in 1904. The site became known as Park Works, and changed ownership on a number of occasions, becoming successively Arthur Lyon & Co., then Newage Engineering and Cummins Generator Technologies.

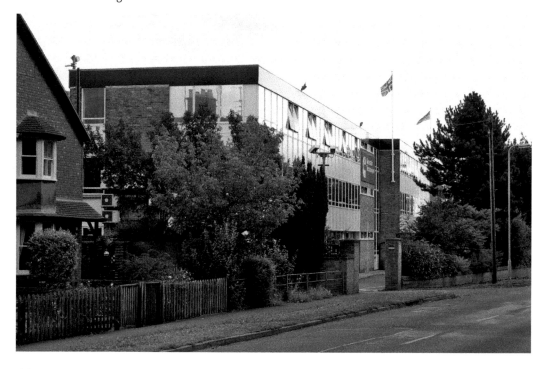

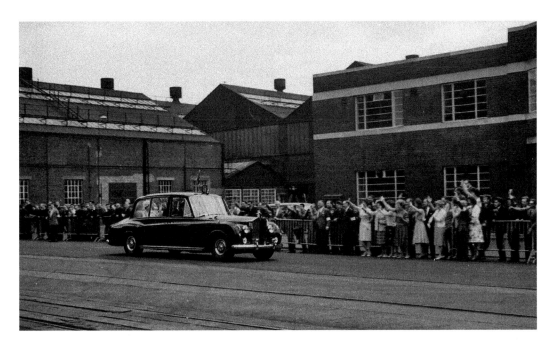

Blackstones

For many years Blackstones was one of the town's largest employers. The company had its origins in the engineering firm founded by Henry Smith in Sheepmarket in 1837. In 1845 the firm moved to St Peter's Street where the Rutland Terrace Ironworks was established. But by 1886 the firm had outgrown its premises and it moved to a large site adjacent to the Stamford to Essendine Railway. The first building on the new site was opened in 1887. It eventually closed completely in 2003 after 165 years of business. This photograph shows a royal visit to the factory probably at the time of the 1961 Quincentenary celebrations. After closure part of the site became a retail park, while the remainder is still awaiting a suitable use.

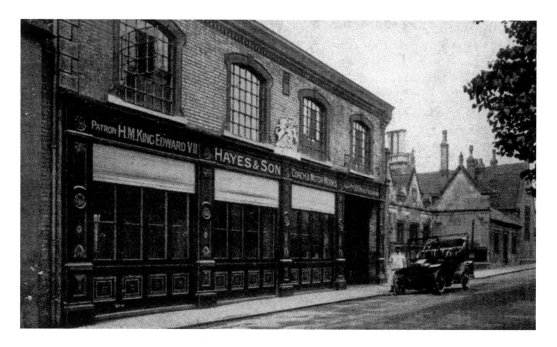

Hayes & Son, Scotgate

This company had a considerable output of carriages and wagons and exhibited nationally. Their Scotgate showrooms were built in 1878 on the site of the old Traction Engine pub. After the closure of the Hayes company in 1924 it became the town fire station until the opening of the new fire station in Radcliffe Road. The building was demolished in 1967 to make way for a car park.

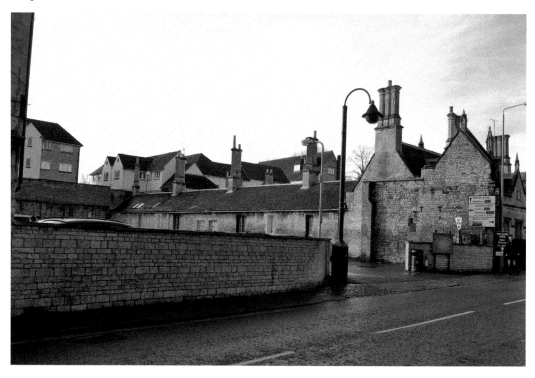

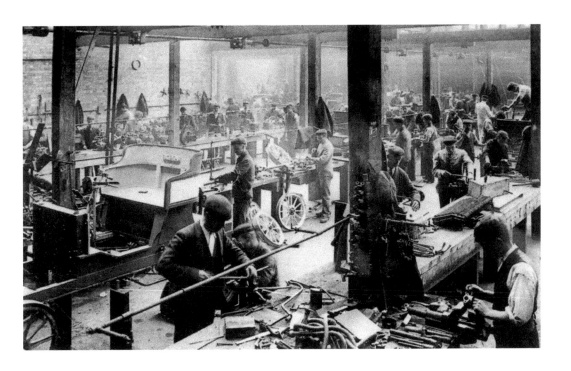

Pick Motor Works in Gas Lane

Jack Pick manufactured cars in Stamford between 1900 and 1925. Like many other motor manufacturers, Pick began by building cycles and then moved into building cars with the production of a two-seater with a dog-cart style body. The Pick car in the modern photo is a 1912 Doctor's Coupe.

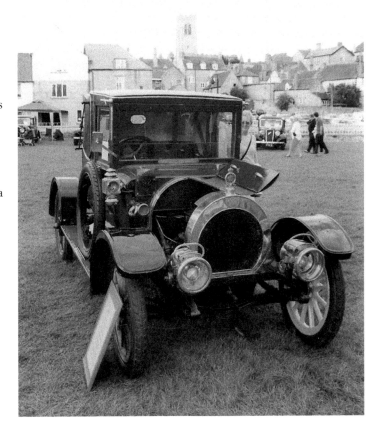

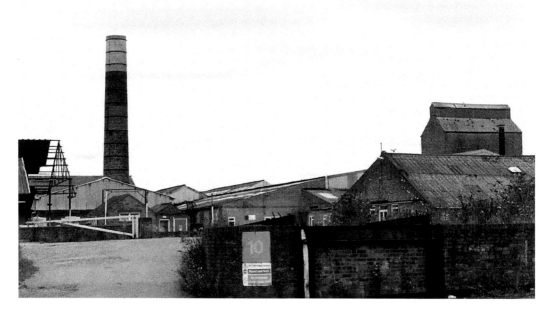

Williamson Cliff

Williamson Cliff Ltd., brickworks, was established in 1907 as Towers & Williamson. Williamson Cliff Ltd had taken over by 1930. The company made a wide range of bricks, including hand made facing bricks. In its adverts the company boasted that Churchill College Cambridge was one of many university buildings in Stamfordstone. The site was cleared in 2007 for further housing development.

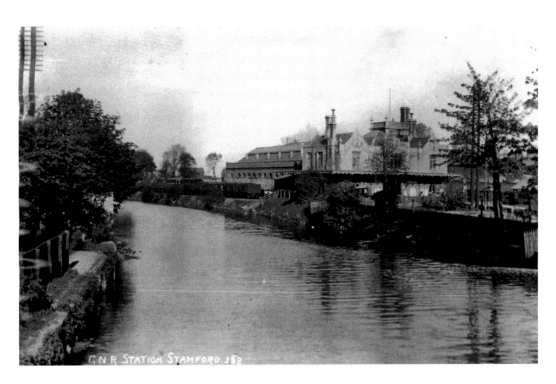

GNR Station

GNR Station in Water Street was built to connect Stamford with the GN line at Essendine, four miles to the north. The station was built in 1855 in a style that reflects Elizabethan architecture. The line was opened in November 1856 and closed in March 1957. All that remains of the original structure is the station building, which has now been converted to two houses.

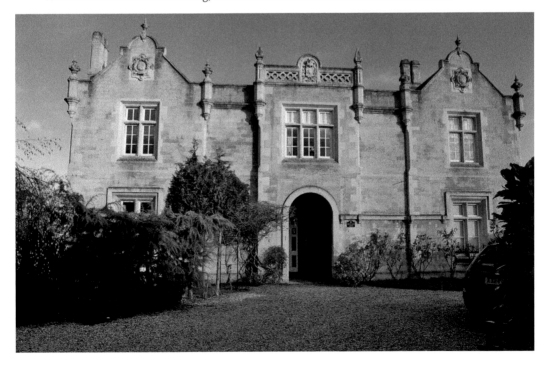

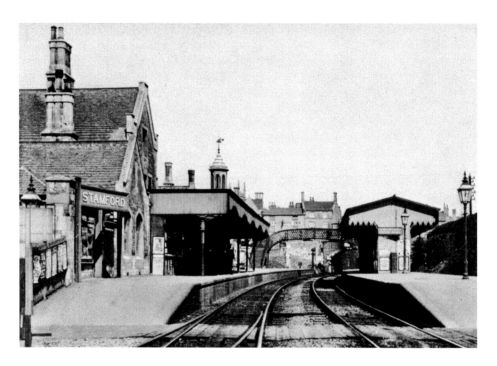

The Midland Railway Station

The Midland Railway Station in 1912. One of the posters on the right is for a magazine containing pictures of the *Titanic*, presumably before her ill-fated voyage. The Telegraph Inn can be seen in the centre of the picture. The modern picture reflects a scene that is almost unchanged, although the Seaton bay on the right-hand side of the island platform has now disappeared, and work is now underway to re-align the platforms in order to get longer goods trains through the station.

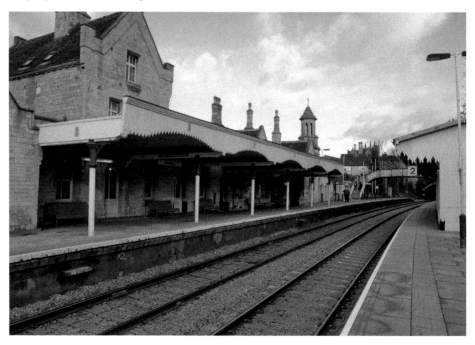

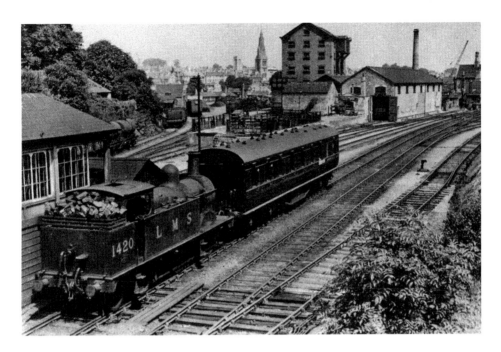

Stamford/ Peterborough Line

The line between Stamford and Peterborough was opened on 2nd October 1846 and the Syston Peterborough line finally completed in 1848. The earlier photograph dates from 1949, and clearly shows the extent of the sidings to the north and west of the station. As can be seen in the second photograph, the modern housing complex completely covers the area of the sidings. Note that the redundant signal box has now been moved adjacent to the station.

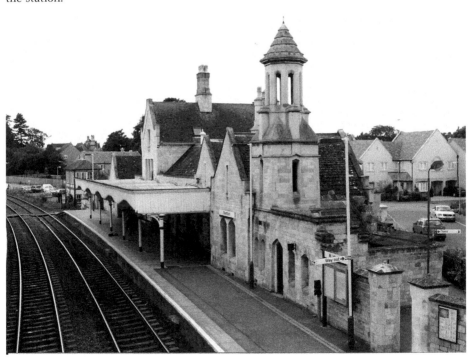

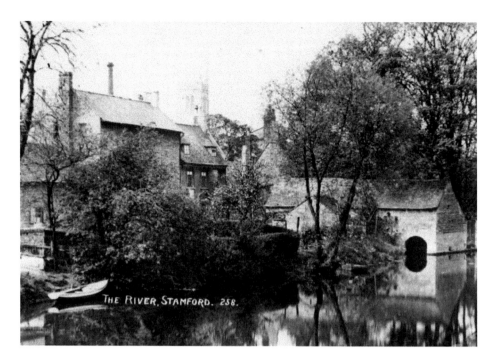

The River Welland in Water Street

Station Road was created in 1849 to provide access to the Midland Region railway station. The George Hotel cockpit was demolished to make way for a road. For many years it also served as a stopping place for buses. Just beyond the last bus shelter can be seen Godfrey & Co timber merchants. The buildings at the west end of the road have now been replaced by a small housing development.

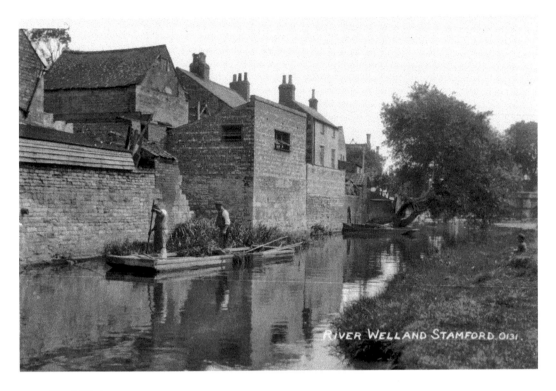

RIVER WELLAND STAMFORD. 0131.

The Millstream

This photograph is of what we now call the millstream, which was then much wider. The buildings are the backs of the properties that once stood along Bath Row. As has often been the case in Stamford, the removal of old houses results in yet another car park.

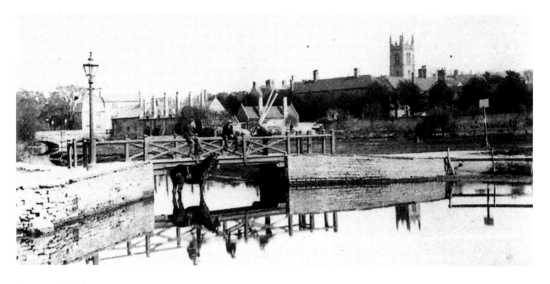

Lammas Bridge

The bridge shown here was later replaced by a cast-iron structure produced by Gibson's Foundry in Broad Street. This, in turn was replaced by the slender structure we see today.

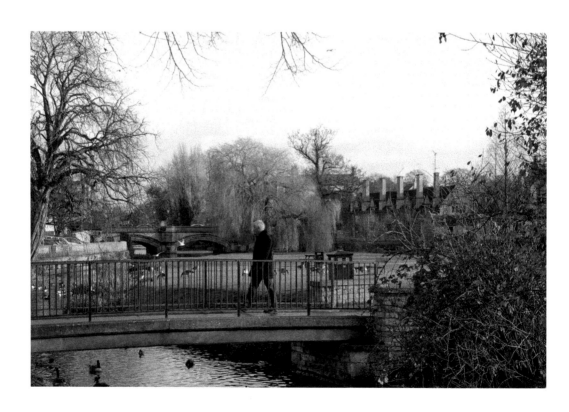

Castle Dyke

This photograph, taken from the end of the Lammas Bridge, looks along Castle Dyke towards the Golden Fleece in Sheepmarket. The cottage with the mansard roof has now disappeared and houses in Warrene Keep occupy part of the site; otherwise, the scene has changed very little. To the south-east of the bridge once stood the town bull ring, where the so called sport of setting dogs against a bull took place.

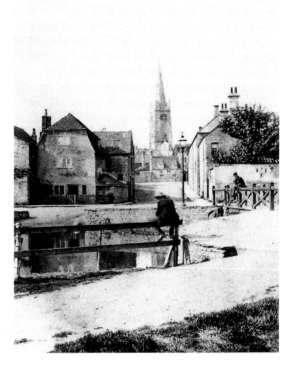

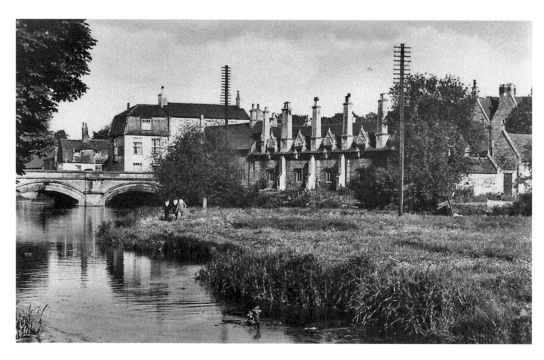

The Meadows
This view of the meadows, looking towards the town bridge, shows the extent to which the mill race has been filled in.

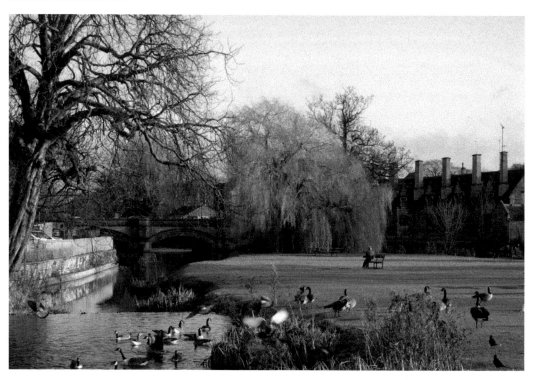

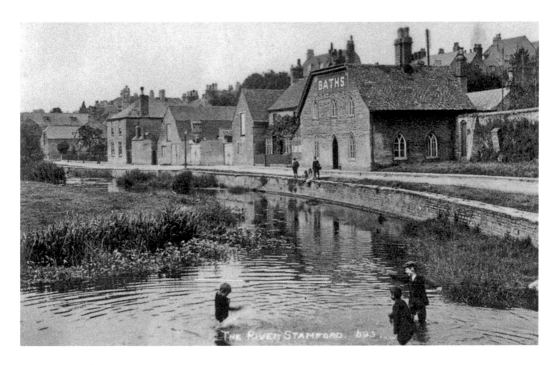

The Bath House

The title of this picture is not quite correct since this is not the river but one of the mill ponds, which have now been filled in to produce what we now refer to as the mill stream. In the background can be seen the public Bath House which, according to George Burton was established by four local doctors in 1722. The baths were rebuilt by the Exeter Estate in 1828. The cost of hot and cold baths were first class 1/- and second class 6d.

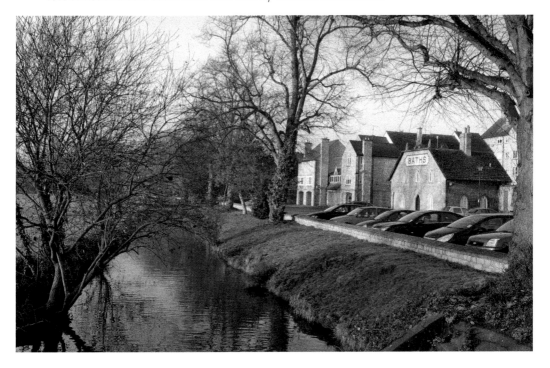

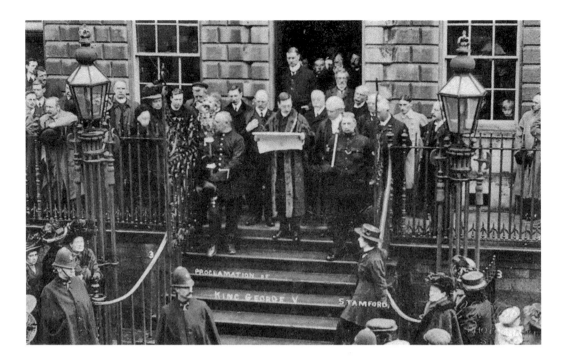

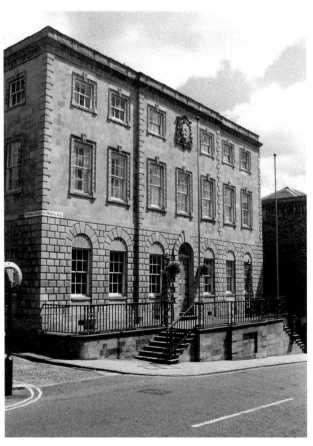

The Town Hall Steps

Important announcements were often made from the Town Hall steps. In this picture the Mayor is proclaiming the accession of George V. As can be seen from the modern photograph, the alignment of steps was changed and the imposing wrought iron gates removed.

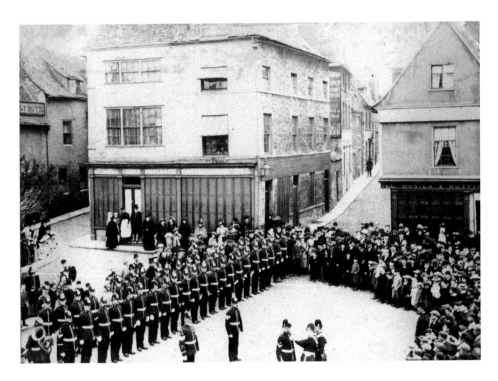

Red Lion Square

In the nineteenth and early twentieth centuries Red Lion Square was frequently used for military parades such as that shown here. This parade took place in August 1895 and shows D Company of the 2nd V Battalion of the Lincolnshire Regiment receiving long service medals. The gentleman in the top hat stood in the doorway of Smiths Wine Merchants is wearing the uniform of Browne's Hospital.

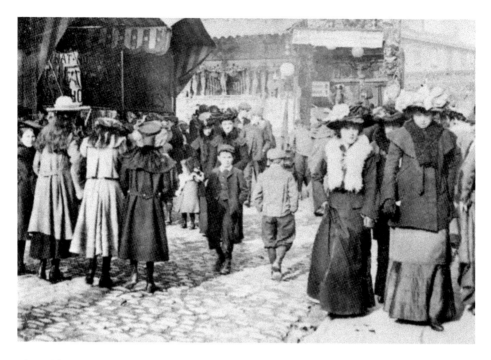

The Mid-Lent Fair

Today the mid-Lent fair is very much about fairground rides and amusements. Its origins however, lie in the fairs of the middle ages. In the nineteenth century the fair was for horses on the Monday before mid-Lent; on mid-Lent Monday for beasts, sheep and horses and the remaining part of the week for haberdashery, toys and amusements. This photograph dates from 1906.

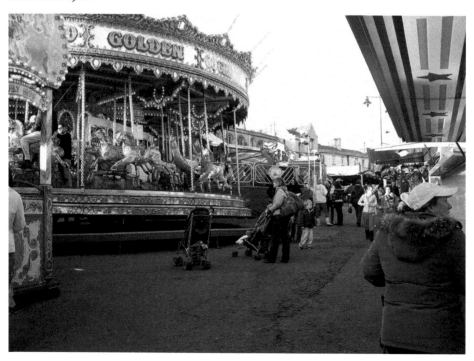

Carnival Parade

A small part of a carnival parade in St Martin's. This is thought to be the Whitsun holiday carnival parade in the 1950s or early '60s. The parade started from the recreation ground and wound its way through the town to the football field on Wothorpe Road.

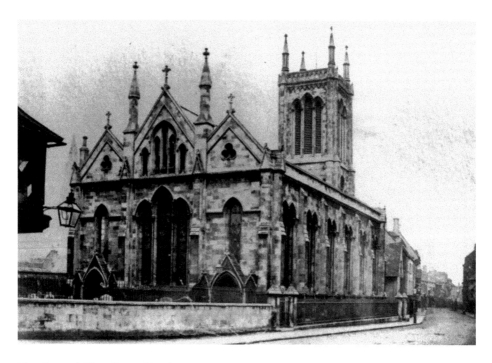

The Second Church on this Site

St Michael's was rebuilt in 1836 following the collapse of the earlier medieval building. It was designed by John Brown of Norwich and cost in the region of £4,000. At the time of its opening, it was described by the *Stamford Mercury* as 'one of the most beautiful buildings in the kingdom'. In May 1963 the church became redundant, and the parish was joined with that of St Mary's. The building lay dormant for some years, and deteriorated quite badly. Following much discussion and various proposals for the use of the building, it was finally bought by a developer in 1982. The interior was then gutted and divided it into shop units.

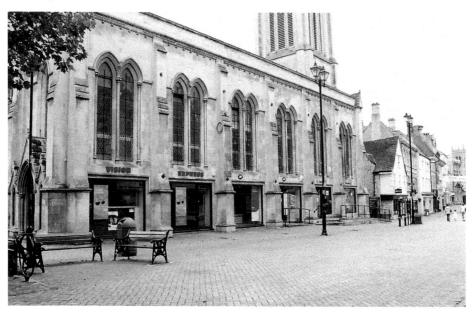

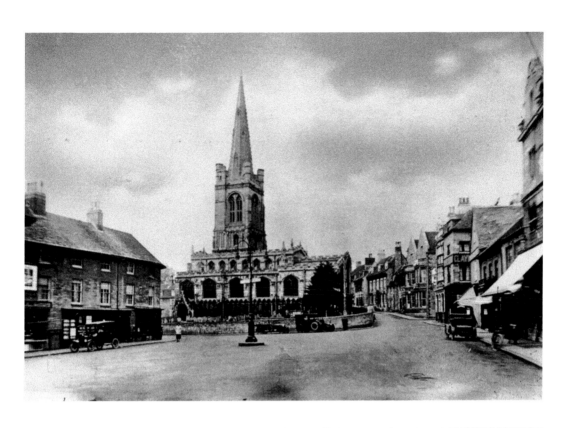

All Saints Church

All Saints church stands in the middle of one of Stamford's medieval markets, now All Saints Place and Red Lion Square. The main part of the existing church is thirteenth century although much rebuilding was done in the fifteenth century under the auspices of the wealthy wool merchant, William Browne.

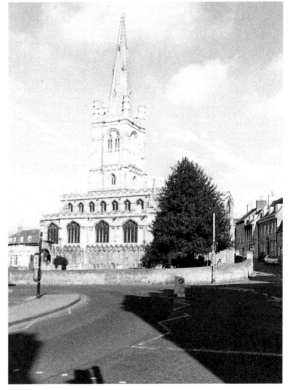

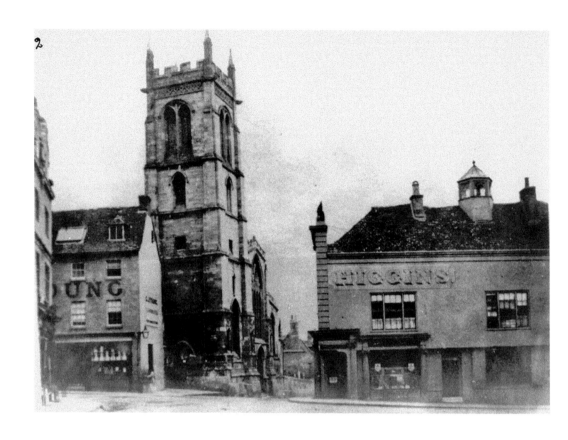

St John's Church

St John's church closed some years ago, and is now in the care of the Historic Churches Preservation Trust. The present building is entirely in the fifteenth century. Stylistically, the church is very similar to St Martin's in Stamford Baron.

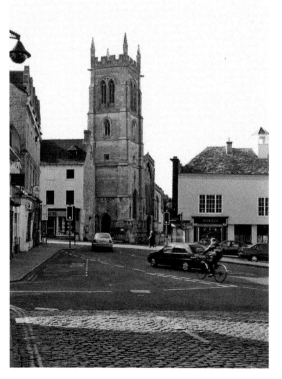

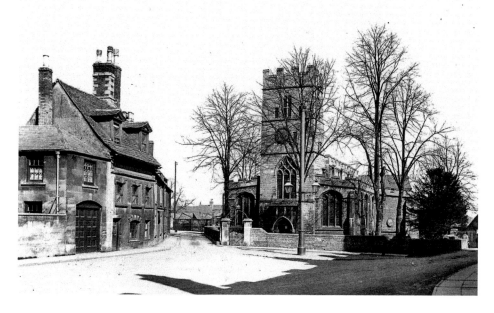

St George's Church

Tucked away as it is, St George's church is often missed by casual visitors to the town. It is possible that this was one of the four churches known to have existed in 1086. However, the present building is mostly of the fourteenth century, although the church was restored in the fifteenth century due to a bequest from Sir William Bruges, Garter King of Arms. The general scene in the square has changed very little, although the low-lying buildings in the middle distance were removed some years ago.

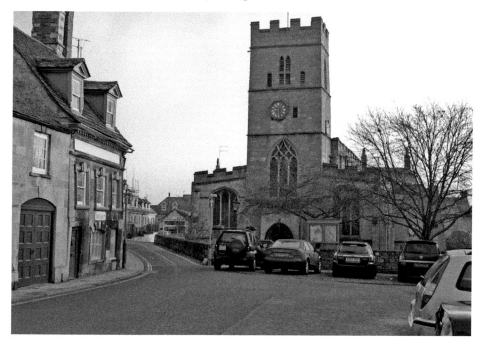

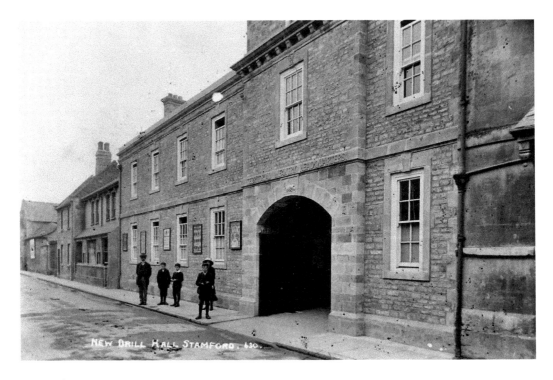

St Peter's Court

The Territorial Army Drill Hall was built in 1913 in a Georgian style. Having served many ears as the base for Territorial members of the Lincolnshire Regiment, it has now been converted to houses and is known as St Peter's Court.

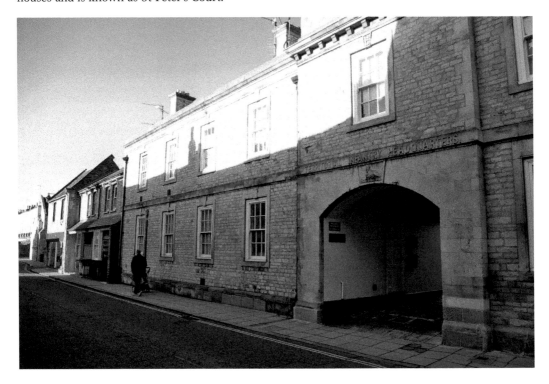

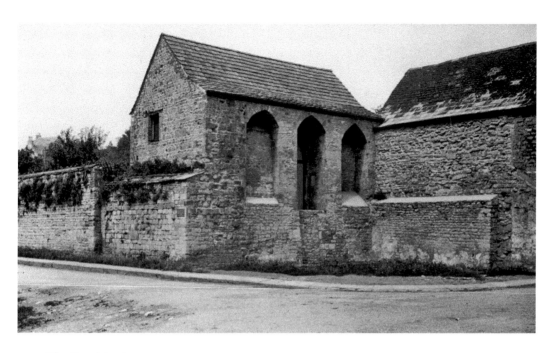

The Court Leet

These fourteenth century arches are all that now remain of the castle buildings. They relate to the castle's great hall, and on Knipe's map of 1833 the building is still referred to as the Court Leet. For many years this is where the mayor of Stamford came to be sworn in at the beginning of his term of office.

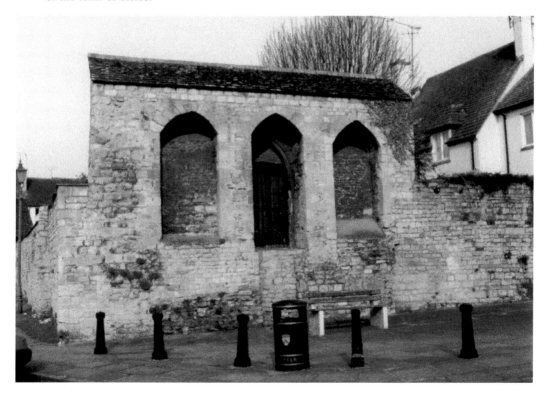

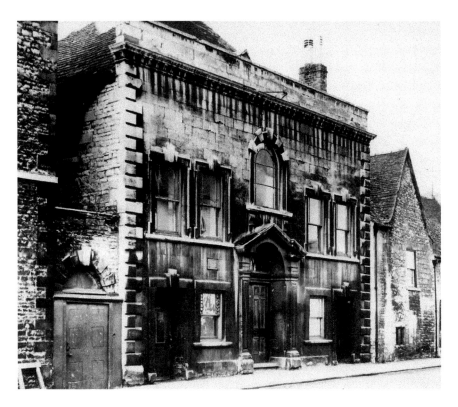

Stamford Theatre

Stamford Theatre now forms an important part of the Arts Centre complex. Opened in March 1768, the theatre had been closed for some years, and fallen into disrepair. It had closed as a theatre in 1871 and became the Stamford Chess, Billiards and News Club. However, the theatre was renovated in the 1980s and re-opened by the Duchess of Gloucester on 18 November 1987.

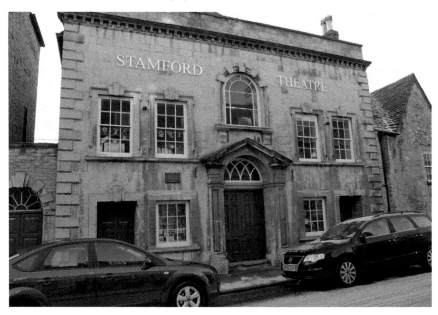

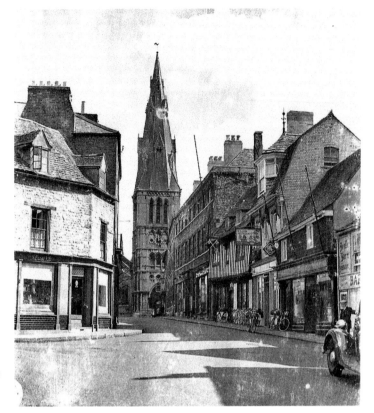

St Mary's Street in the 1950s
The street is remarkably quiet given that, at that time, it formed part of the A1 through Stamford. The Cross Keys pub was still open at that time, so the cyclists could be in there or at the Willow café next door.

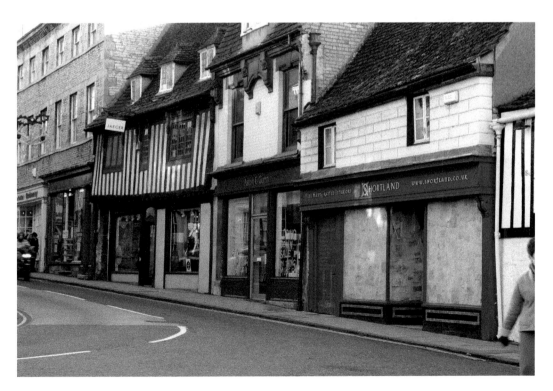

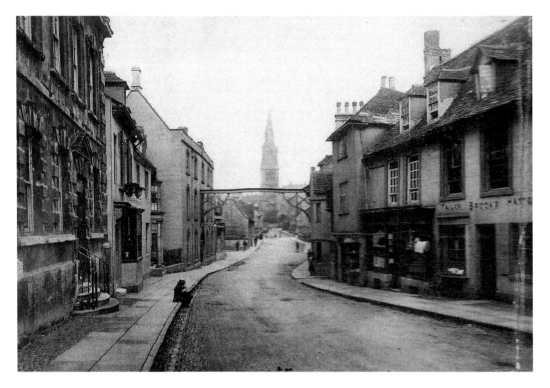

High Street St Martin's

High Street St Martin's presented a very different picture early in the twentieth century. There were quite a number of shops in the street, and these at the northern end of the street were demolished in 1969 to make way for a number of flats designed by the Cambridgeshire architect Marshall Sisson.

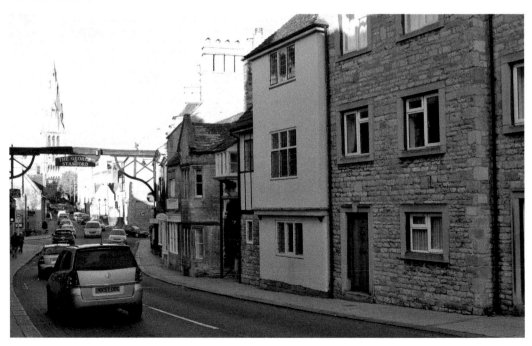

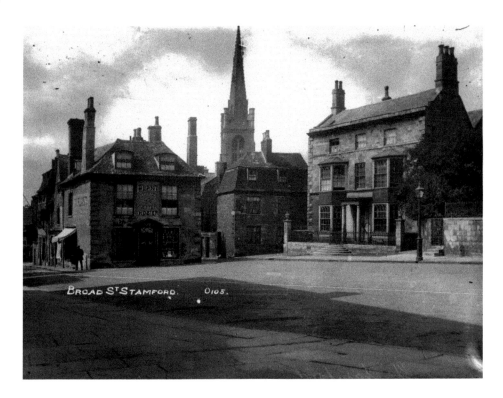

Broad Street

Although the motorcar now dominates the scene, this view of the west end of Broad Street is remarkably unchanged. On the right-hand side of the photograph is No 1 Broad Street; in 1714 Thompson and Bailey the first printers of the *Stamford Mercury* took the lease of this house. The house with the mansard roof in the centre of the picture has now been demolished.

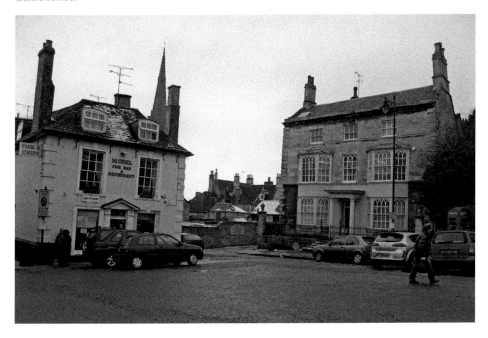

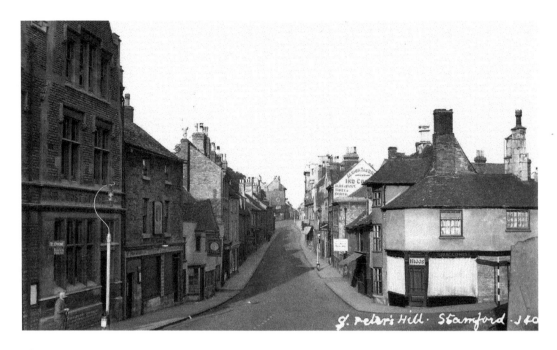

All Saints Street

In the medieval period the street from Red Lion Square to St Peter's Gate was known as the Gannock. Later it became known as Peterhill and it was not until the nineteenth century that it became divided and All Saints Street was given its name.

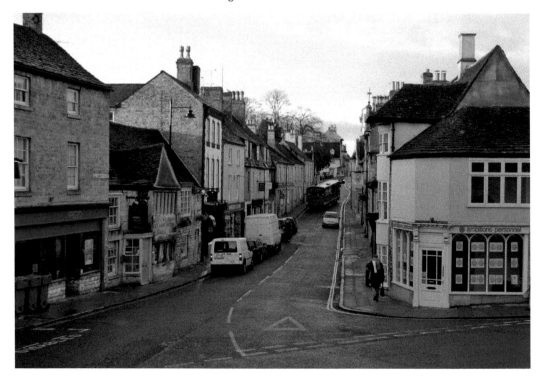

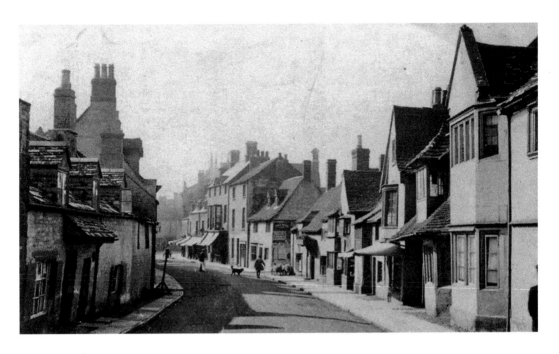

St Pauls Street

This photograph of the west end of St Pauls Street, shows that cottages that were demolished on the south side. It also clearly shows the narrow entrance into Star Lane before No 5 was demolished. Note the sheep outside the Half Moon.

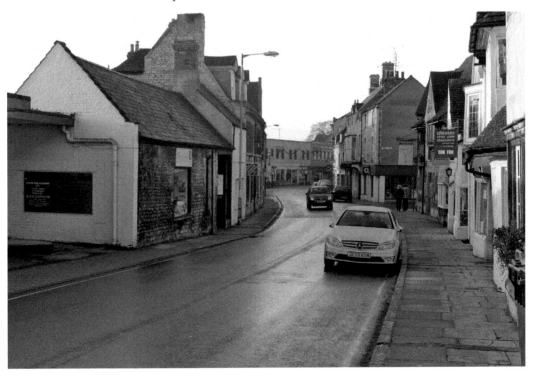

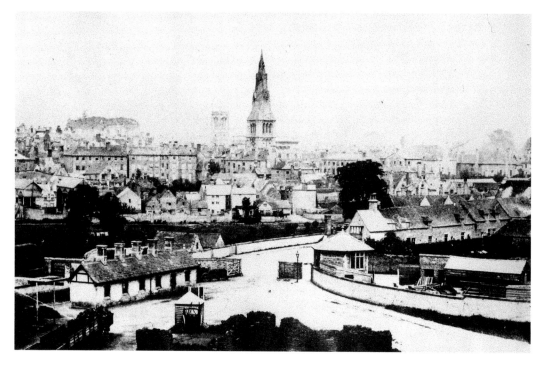

View from the Grain Tower

This early photograph was taken from the grain tower in the station yard looking towards the town. The extent of the station yard can be clearly seen here, as can the buildings on Bath Row. The grain tower was demolished in 1969 following a fire which severely damaged the structure.

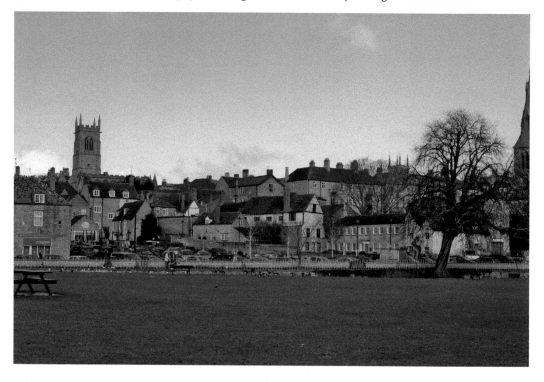